I Do!

The Great
Celebrity
Weddings

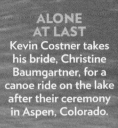

**ALONE
AT LAST**
Kevin Costner takes
his bride, Christine
Baumgartner, for a
canoe ride on the lake
after their ceremony
in Aspen, Colorado.

CONTENTS

Editor **Serena French** Creative Director **Rina Migliaccio** Art Director **David Jaenisch** Fashion Director **Susan Kaufman** Picture Editor **Lindsay Tyler** Writers **J.D. Reed, Elayne Fluker, Moira Bailey** Reporters **Danielle Anderson** (Chief), **Charlotte Triggs, Megan Gambino, Laura J. Downey, Debra Lewis** Photo Assistant **Donna Tsufura** Copy Editors **Tommy Dunne, Ellen Adamson, Lance Kaplan** Production Artists **Michael Aponte, Nora Cassar, Denise Doran, Ivy Lee, Michelle Lockhart, Cynthia Miele, Daniel Neuburger** Scanners **Brien Foy, Stephen Pabarue** Special thanks to: Elaine Francisco, Robert Britton, Sal Covarrubias, Margery Frohlinger, Charles Nelson, Susan Radlauer, Annette Rusin, Ean Sheehy, Jack Styczunski, Céline Wojtala, Patrick Yang

Time Inc. Home Entertainment
Publisher **Richard Fraiman** Executive Director, Marketing Services **Carol Pittard** Director, Retail & Special Sales **Tom Mifsud** Marketing Director, Branded Businesses **Swati Rao** Director, New Product Development **Peter Harper** Assistant Financial Director **Steven Sandonato** Prepress Manager **Emily Rabin** Marketing Manager **Laura Adam** Associate Book Production Manager **Suzanne Janso** Associate Prepress Manager **Anne-Michelle Gallero** Associate Marketing Manager **Danielle Radano**

Special thanks to: Bozena Bannett, Alexandra Bliss, Glenn Buonocore, Bernadette Corbie, Robert Marasco, Brooke McGuire, Jonathan Polsky, Chavaughn Raines, Ilene Schreider, Adriana Tierno

NEWLYWEDS
Kerr Smith of
Dawson's Creek and
actress Harmoni
Everett married in
June 2003 at
a resort in Palm
Springs, Calif.

W

hat's the most romantic thing you've ever imagined? Saying "I do" in a hilltop ceremony on the isle of Capri or wearing the gown of your dreams to the beach and making a vow in the sand? Dreams come true, as these star marriages prove. From Matt LeBlanc's week-long celebration in Kauai to Kevin Costner's lakeside ceremony in Aspen, these unique nuptials have the glamor, the grandeur, the surprises and the heartfelt moments—the most personal expression of an important rite of passage. You're invited to Palm Beach and the French Riviera, Australia and the opulent backyards of L.A., for an intimate look at 100 of the most unforgettable weddings.

HUSH HUSH
Actress Julia Roberts and her future husband, cameraman Danny Moder, at the opening of *Ocean's Eleven* in December 2001. The couple married on the quiet in July 2002.

SECRET WEDDINGS

As stars head to the altar, some choose
to make it a very private affair

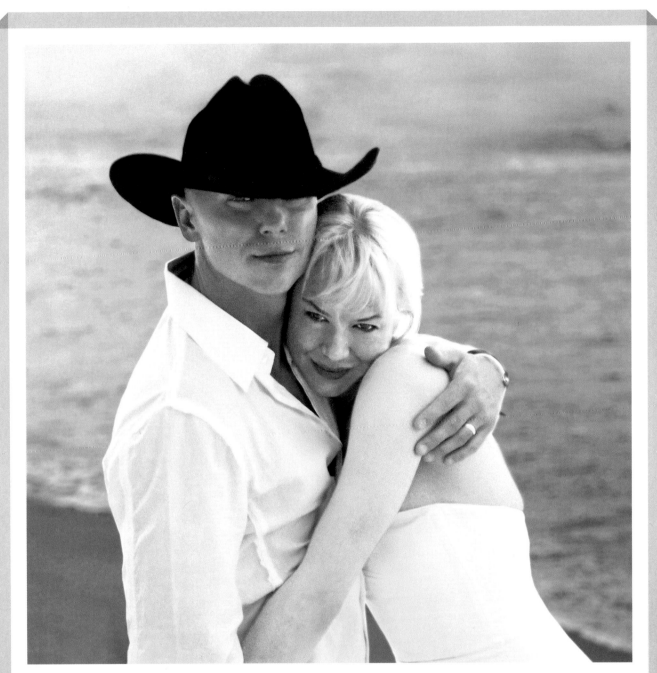

renée zellweger & kenny chesney

MAY 9, 2005 "You had me from hello." Yes, the Oscar winner's *Jerry Maguire* signature line became the title of a hit for the country heartthrob, and that probably explains their quiet rush from intro to altar. Neither had been married and both were emerging from long, failing relationships. Once they met in January at NBC's Concert of Hope tsunami relief telethon, where Chesney performed and Zellweger answered phones, they began e-mailing each other constantly and holding what a friend calls "secret meetings" in places like San Diego, where paparazzi rarely prowl. "From the second she met him, it was love at first sight," said a friend of the couple's. A mere four months later, Zellweger, 36, and Chesney, 37, surprised pals and the press with a low-key wedding on St. John in the Virgin Islands, where Chesney has a home. The only departure from the sandals-and-shorts vibe was Zellweger's strapless, bamboo-twill gown by favorite designer Carolina Herrera. As a spectacular Caribbean sunset blazed across Chesney's hilltop property, the couple exchanged traditional vows before a minister and a small party of friends and family. "It was very spare," said a guest. "It wasn't about grand gestures and $40,000 displays of flowers. It was about two very happy people finding each other." Said Chesney: "I'm the luckiest man alive."

britney spears & kevin federline

SEPTEMBER 18, 2004 "Surprise! It is with much love that we welcome you to our wedding ceremony tonight," read the cards handed to 27 astonished friends and relatives, including the bride's parents, who thought it was an engagement party. It was a minor miracle that the do remained sub rosa. The 22-year-old pop star, after all, even has trouble keeping family Christmas presents a secret. But the pressure—and the paparazzi—building up toward her lavishly planned October 16 nuptials at celeb-favored Bacara Resort in Santa Barbara, California, to fiancé Federline, 26, was, she said, "this huge thing, and I was like, 'What are we waiting for?'" So planner Alyson Fox transformed her own Studio City, California, living room to spring it on the invited guests a month early. (The wedding party thought the bride merely hyper-organized when dress fittings had been arranged so far in advance.) Spears, splendid in a $26,000 Monique Lhuillier gown with a hand-sewn train and cathedral-length veil, exchanged nondenominational vows with the groom in a 15-minute ceremony. When she dropped Federline's wedding ring, the minister said, "Don't worry. It's a good sign." For the backyard tented reception featuring pink champagne and down-South fare of fried chicken fingers, sweet-and-spicy ribs and mashed potatoes, the bride changed into another Monique Lhuillier creation, this one a lace micromini dress. Later the couple and their party donned matching team sweats—Pimps and Mrs. Federline in white, The Maids in pink—and took off clubbing into the wee hours. Federline readied a wedding-night surprise by having the presidential suite at the Hotel Bel-Air strewn with rose petals, gardenias, Swarovski crystals and 250 candles. The whole day was to the bride's liking, and documented in their reality show *Britney and Kevin: Chaotic*. Said she: "I'm just kind of happy that we pulled off the whole thing."

CROSSROADS Britney and Kevin cut their Perfect Endings cake. Britney gets buttoned into her Monique Lhuillier gown by bridesmaids. Mugging with mom Lynne, who said, "I just cried because I think it sort of hit me that she is a woman now."

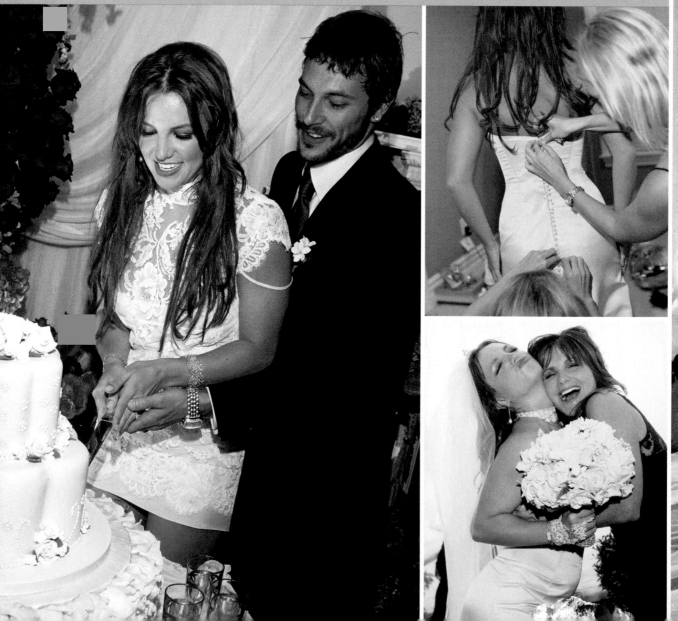

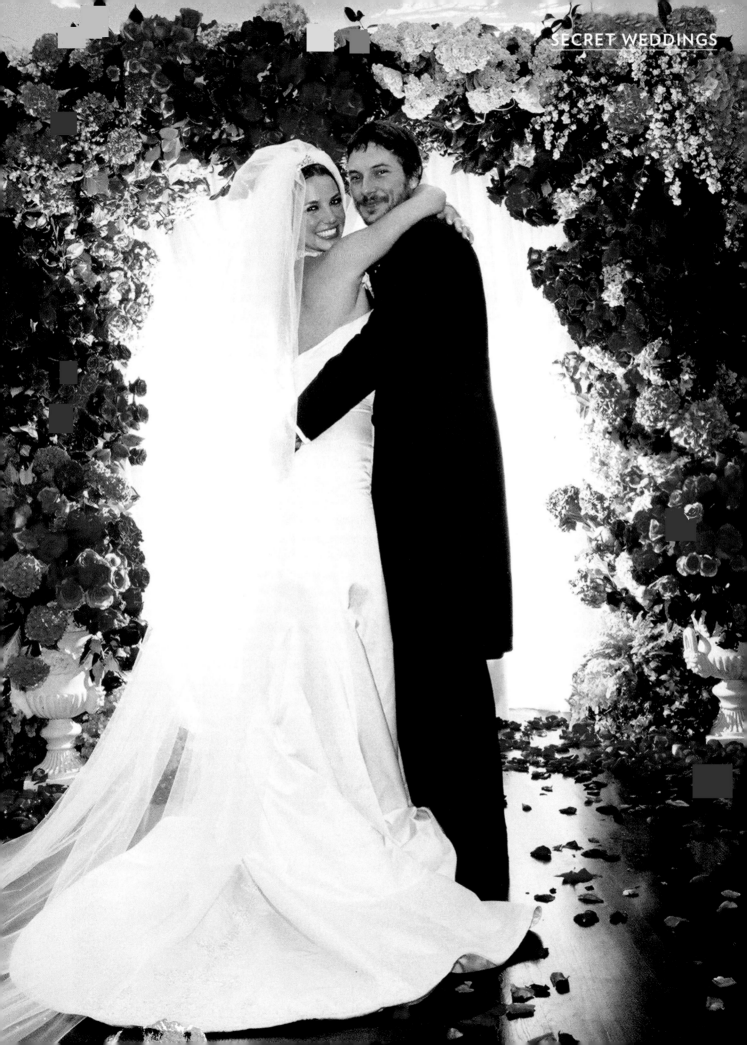

jennifer lopez & marc anthony

JUNE 5, 2004 After the Rolls-Royces, mega-bling and galactic hype of Bennifer, this wedding—his second, her third—was low-key indeed. Approximately 35 friends and family gathered at Lopez's Beverly Hills estate for what they thought was an afternoon party. "She saw this as a whole different kind of wedding," said gown designer Vera Wang. "More intimate, far less of a production." Certainly less than the $2 million almost-do she'd planned with Ben Affleck nine months earlier, which was called on account of cold feet. The actress, who served as chief wedding planner and pulled the affair together in about three weeks, exchanged vows beneath a rose-covered canopy with the Armani-clad Anthony.

"Marc has been crazy about her for years," said pal Rosie O'Donnell. "This is the realization of a great romantic dream for him." As for Lopez, one insider said, "she just wanted to get married to the man she loved, and she didn't have to prove her love to anyone but him." Afterward, a deejay got guests moving with tunes like Diana Ross's "Upside Down." Along with caviar and champagne, refreshments featured Coors Light on tap—Anthony's brewski of choice. "There was a lot of mingling," said a guest. "Everybody got a chance to visit and hug." And then, in good Hollywood tradition, it was back to the grind. Less than 48 hours after the wedding, Lopez was on the set of her movie *Monster-in-Law*—bashfully accepting congratulations from costar Jane Fonda—and Anthony was packing for the East Coast to promote his album *Amar Sin Mentiras (To Love Without Lies)*.

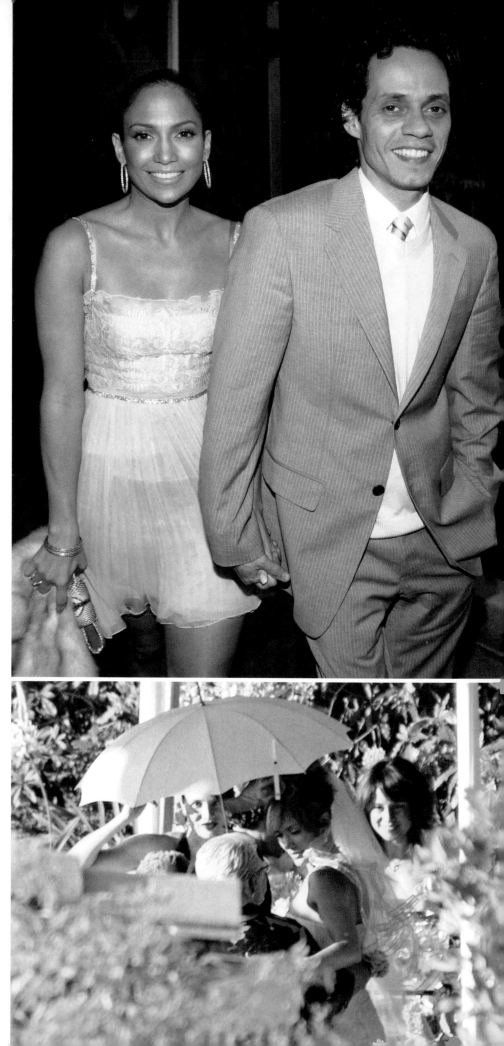

heidi klum & seal

MAY 10, 2005 They didn't want to wed in grand "Donald Trump style," the bride said. "That's not us." Good thing. They couldn't have topped their engagement five months earlier. The 42-year-old British pop star proposed to German supermodel Klum, 31, on a 14,000-foot-high glacier in British Columbia "in an igloo built just for the moment," said Seal. Their nuptials were far less dramatic—and less chilly. To keep the press off-track, they said their nondenominational vows at sunset near Seal's home on Mexico's Costa Careyes, with only the officiator in attendance. Some 40 friends were invited to join them afterward at Seal's estate. The affair was relaxed, but not without its touch of style. Klum, who was five months pregnant with the couple's baby, and her daughter from a past relationship, 1-year-old Leni, wore identical Vera Wang ivory Chantilly lace gowns. "There's so much love in the air," said a friend. "This is a natural progression in their relationship."

ben affleck & jennifer garner

JUNE 29, 2005 In a feat fantastic enough to rival the superhero powers of Daredevil and Elektra, actors Ben Affleck and Jennifer Garner managed to elude the press, paparazzi and even their parents when they pulled off a small, secret wedding ceremony. The couple of one year, who got to know each other while filming *Daredevil* in 2002, escaped to Parrot Cay, an island in Turks and Caicos, and exchanged vows in front of one confirmed guest, Garner's *Alias* father Victor Garber. Quite a contrast from the planned $2 million spectacle of Bennifer No. 1 (with Jennifer Lopez). According to Affleck friend, director Don Roos, "Most of Ben's friends thought [his Lopez era] . . . with all the bling and excesses, seemed a bit out of character. His relationship with Garner seems more who he is. He really is an ordinary guy, and she's an ordinary girl." Much to the couple's dismay, the media watch on their relationship was so extraordinary they were afraid to tell even family. Close friends—none of whom attended the nuptials—say they understand. "They're in it for one another, not for anyone else," said Affleck's pal, director Kevin Smith. Added longtime friend, producer Chris Moore, "I'm so happy they pulled off such an intimate, private event. That wasn't easy."

The celebration consisted of relaxing in the two-story oceanfront house that belongs to actor Bruce Willis (who also wasn't there) as Garner, who was pregnant with the couple's first child, stayed out of the heat. Said Moore: "Ben's got the right woman and he's excited about this new chapter in his life. He's real excited about becoming a father, and Jen seems ecstatic."

HOW THEY MET

Billy Joel, 55, and **Katie Lee**, 23, in the lobby of Manhattan's Peninsula Hotel, where they both happened to be staying.

◆

Jason Priestley, 35, and **Naomi Lowde**, 29, in the street in London, where he was starring in *Side Man*.

◆

Adam Sandler, 37, and model-actress **Jackie Titone**, 29, at a party at Stephen Dorff's house.

◆

Kate Beckinsale, 30, and director **Len Wiseman**, 31, on the set of *Underworld*.

◆

Carmen Electra, 31, and **Dave Navarro**, 36, went on a blind date.

◆

Ashleigh Banfield, 36, former MSNBC anchor, and real estate financier **Howard Gould**, 31, while walking their dogs in Central Park. The leashes became entangled and the owners started talking.

◆

Crown Prince Frederik of Denmark, 35, one of Europe's most eligible bachelors, met commoner **Mary Donaldson**, 32, a law school graduate from Tasmania, in a Sydney pub during the 2000 Olympics.

◆

Elizabeth Berkley (*Showgirls*), 31, and painter **Greg Lauren**, 33, Ralph's nephew, at dance class.

◆

Kate Winslet, 28, and *American Beauty* director **Sam Mendes**, 38, met in August 2001 when he asked her to do a play. She declined, but they began dating soon after and married in May 2003.

◆

Taye Diggs, 32, of *Kevin Hill*, and **Idina Menzel**, 31, the Tony Award-winning star of *Wicked*, while starring together in the original 1996 production of *Rent* on Broadway.

Kyle MacLachlan, 43, and publicist **Desiree Gruber**, 34, met in an L.A. chiropractor's office. They wed three years later in Gruber's hometown of Miami.

Joey McIntyre, 30, former New Kid on the Block and *Boston Public* star, and **Barrett Williams**, 25, met when McIntyre became the L.A. real estate agent's very first client. She didn't know who he was until coworkers told her.

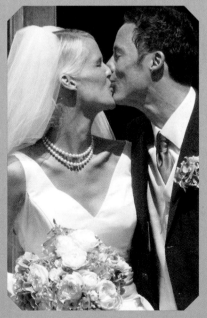

Tom Cavanagh, 35, star of *Ed*, and **Maureen Grise**, 33, a photo editor at SPORTS ILLUSTRATED, on a New York City basketball court.

ELOPEMENTS
SOMETIMES IT'S BETTER JUST TO RUN OFF

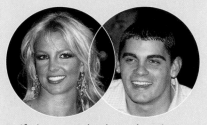

If it's past midnight and you're in Las Vegas, elopement could be likely but probably not recommended. **Britney Spears** and childhood pal **Jason Alexander** became more than friends in January 2004 at A Little White Wedding Chapel but called it quits after two days.

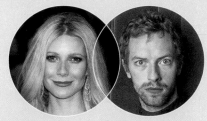

Outside of Vegas, your chances improve: Sealing a 15-month relationship, with a baby on the way, **Gwyneth Paltrow** and **Chris Martin** kept their plans quiet in December 2003 when they got a license at the Santa Barbara County courthouse and married in a surprise ceremony after.

Nicky Hilton married New York money manager and family friend **Todd Meister** in August 2004 at 2:30 a.m. at the Vegas Wedding Chapel, during a party weekend with her sister Paris and an entourage of friends. Two months later, the pair began working on an annulment.

Nicolas Cage's brother Marc Coppola said he figured his famous sibling's wedding would be "fast and small." Cage married former sushi waitress **Alice Kim** in July 2004 on a ranch in Northern California, just six months after they met at a Los Angeles nightclub.

Kate Winslet said her June 2003 wedding to Oscar-winning director **Sam Mendes** wasn't planned but seemed like "a good idea" while on an Anguilla vacation. Three close friends and Winslet's daughter Mia (from a previous marriage) witnessed vows in a garden by the beach.

BIGGEST WEDDINGS

Spain's Crown Prince Felipe: 1,400 guests
Prince Charles: 750
Wynonna Judd: 600
Luciano Pavarotti: 600
Star Jones: 450
Donald Trump: 450
Rudy Giuliani: 400
Adam Sandler: 400
Nick Lachey & Jessica Simpson: 350
Tori Spelling: 350
Geraldo Rivera: 350
Kevin Costner: 320
Paul McCartney: 300

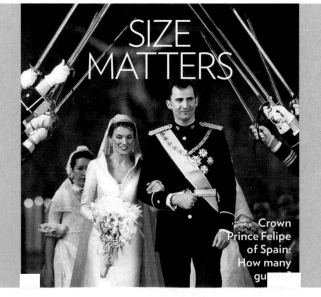

SIZE MATTERS

Crown Prince Felipe of Spain: How many guests?

SMALLEST WEDDINGS

Russell Crowe: 80 guests
Matt LeBlanc: 75
Sarah Michelle Gellar: 60
Julia Roberts: 60
J.Lo & Marc Anthony: 35
Heidi Klum & Seal: 40
Julianne Moore: 35
Renée Zellweger: 35
Britney Spears: 27
Jennifer Connelly & Paul Bettany: 14
Dennis Quaid: 9
Michelle Branch: 4
Kate Winslet: 4
Richard Gere: 2

julia roberts & danny moder

JULY 4, 2002 The actress had no problem keeping her nuptials to cameraman Moder hush-hush. After all, her 1993 trip to the altar with singer Lyle Lovett was a paparazzo-free affair in the small town of Marion, Indiana. This time, Roberts, 34, invited 60 friends and family members (no celebrities) to her $5 million ranch near Taos, New Mexico, for a July Fourth bash. By nightfall July 3, however, she urged her guests to "stay around." Soon after, the Oscar winner was walking to a candlelit adobe building on her property wearing a pink cotton halter dress by pal Judith Beylerian. She exchanged simple, handwritten vows with Moder, 33, her beau of one year, also on his second marriage. "It was such a magical, intimate gathering," said a friend. "It felt like we were invited into someone else's secret." Roberts's lack of fuss and formality extended to the reception. Guests celebrated by dancing to Bob Marley and Sade played on a malfunctioning boom box. And the next afternoon's all-American wedding feast featured corn on the cob, hamburgers and hot dogs. Nothing more elaborate was needed. "She found the right person," said a friend. "There wasn't a shred of doubt about that on the property."

HOW THEY KEEP THEIR SECRET

HIKE TO THE HILLTOPS OR STAY AT HOME? THERE ARE MANY WAYS FOR CELEBS TO MAKE THE BIG DAY A PRIVATE AFFAIR

When it comes to getting married on the sly, **Madonna**, always the innovator, set the celebrity standard. The invitations to her 1985 marriage to **Sean Penn** said that because of "the need for privacy and a desire to keep you hanging," the 200 guests wouldn't learn the location (a bluff in Malibu) until the day before. Her bluff didn't quite work. News helicopters hovered overhead, but ever since, covertness has become as much a part of the ritual as rice and garters.

NO GOWN, NO TUX
Carey Lowell and **Richard Gere** wed in a field on their estate after seven years together.

JOIN THE CIRCUS

Balloons and big-top tents go beyond Barnum to help provide privacy for three-ring celebrity weddings. Large white balloons floated above Malibu in June 2003—and over groom **Adam Sandler** and bride **Jackie Titone** to help block any flying spying. For **Russell Crowe's** 2003 wedding to **Danielle Spencer,** which took place at his cattle ranch in Australia, helium balloons performed a similar sleight of scenery. Tents also offer cover from the curious. The one shielding **Sir Anthony Hopkins**, bride **Stella Arroyave** and guests attending their March 2003 wedding in Malibu measured 30 feet high.

STAY PUT
Home is where the chatty waiters aren't. **Richard Gere** and **Carey Lowell,** with son Homer and Lowell's daughter Hannah in tow, wed in November 2002 on their Westchester County, New York, property, handily adjacent to a paparazzi-free nature preserve. *Will & Grace's* **Megan Mullally** and **Nick Offerman** said "I do" in her Los Angeles backyard in September 2003. **Stella McCartney** wasn't exactly home but near the family farm when she married **Alasdhair Willis** in August 2003 on the Scottish Isle of Bute (pop Sir Paul arranged a 40-strong security detail for trespassers).

BE CIVIL
Like **Prince Charles** and **Camilla Parker Bowles,** who traded vows at Windsor's town hall in April 2005, some find a civil ceremony more subdued. Alt rocker **Beck** wed *Pleasantville's* **Marissa Ribisi** (six months pregnant with their first child) quietly in Santa Barbara, California. A London registrar officiated for **Elvis Costello** and **Diana Krall** in December 2003 (although another, flashier ceremony followed at the home of friend Elton John).

MAKE 'EM SWEAR
Staffers at the July 2000 wedding of **Brad Pitt** and **Jennifer Aniston** were asked to sign a document saying they'd be held liable for a pretty penalty (up to $100K) if they talked about the wedding. *Survivors* who witnessed the Paradise Island pairing of **Rob Mariano**

and **Amber Brkich** were pledged to secrecy, ensuring that the April 2005 ceremony would be a surprise for CBS viewers watching it a month later.

GET LOST The more you trek, the less the press suspects. Australian pop star **Natalie Imbruglia** and rocker **Daniel Johns** kept guests in the dark and in motion with a three-hour flight from Sydney, a 50-mile drive to a resort near the Great Barrier Reef and a mile (almost) walk to a beach for their "beautifully moving, nontraditional spiritual ceremony" on New Year's Eve, 2003. A year later, on December 29 actress **Gillian Anderson** went to an island off the Kenyan coast instead of a chapel to wed boyfriend **Julian Ozanne**. White Stripes frontman **Jack White** went all the way to Brazil, where three rivers met and a shaman priest in a canoe officiated, to marry model **Karen Elson** in June 2005. Guests at the July 2000 wedding of **Brad Pitt** and **Jennifer Aniston** gathered at Malibu High School for a shorter journey—a five-mile ride aboard shuttles to the Malibu ceremony.

DO IT YOURSELF **Julia Roberts** proved to be a pretty resourceful woman by taking some of the planning of her wedding to **Danny Moder** into her own hands. Roberts was spotted making stops around Taos, New Mexico (near her ranch), buying everything from steel buckets to shrubs and food.

BORROWED OR NEW

In this case, someone's secluded setting. **Selma Blair** and **Ahmet Zappa** took the big step in January 2004 on a candlelit walkway at the Coldwater Canyon, California, home of actress Carrie Fisher. **Melissa Etheridge** and **Tammy Lynn Michaels** became "beloved wives" in a September 2003 ceremony at a chart-topping location: Dick Clark's Malibu estate.

ASK YOUR FATHER If you want to keep it all in the family, dads can offer some valuable wedding venues. Aaron Spelling walked daughter **Tori** down the aisle in a Gatsbyesque gathering for her wedding to **Charlie Shanian** on the grounds of Dad's estate, which features a 56,000-sq.-ft. mansion. **Natasha Gregson Wagner** said her vows in the L.A. backyard of stepdad **Robert Wagner**, made to look Parisian for her October 2003 wedding to screenwriter D.V. DeVincentis. **Jessica Capshaw** wore Vera Wang to wed at the East Hampton estate of stepfather Steven Spielberg. Capshaw, actress daughter of actress Kate, married child psychologist **Christopher Gavigan** in May 2004.

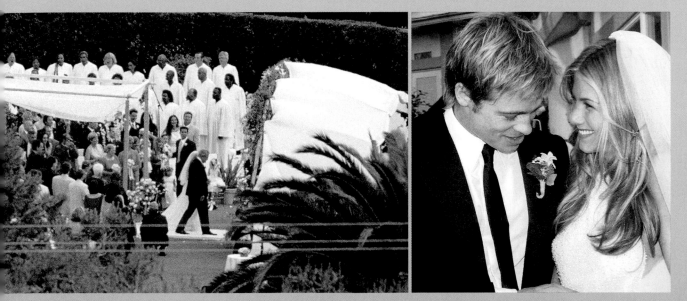

UNDER THE BIG TOP At **Brad Pitt** and **Jennifer Aniston**'s nuptials in Malibu in July 2000, tents shielded the festivities from prying lenses. Planners for Russell Crowe and Adam Sandler used balloons to ruin unwelcome shots of the outdoor events.

I MARRIED A STAR

Celebrities look outside the Hollywood circle and
find love sweet love with everyday people

tori spelling & charlie shanian

JULY 3, 2004 How could it not be over the top? The 1920s-themed wedding of Spelling, 31, and writer-actor Shanian, 35, her boyfriend of more than two years, was held at Hollywood's largest private home: the six-acre, 123-room mansion of the father of the bride, mega-TV producer Aaron Spelling (*The Love Boat, Dynasty, Melrose Place*, etc.). The do carried a Spelling-size price tag, too: an estimated $1 million. The 350 guests—black tie only, please—included Tori's pals, like *Beverly Hills, 90210* castmates Jason Priestley, Jennie Garth and Ian Ziering. After sampling the champagne fountain and an all-white lounge—actually a 10-car garage transformed by planner Mindy Weiss into a pre-ceremony space—they settled in to await a radiant Spelling, who wore a flapperish, $50,000 Badgley Mischka crystal-

LOVE BOAT Spelling had five bridesmaids and two bridesmen. She wore crystal beaded Chantilly lace.

beaded gown. After she was escorted down the aisle, her nervous 81-year-old father "stepped on my train," Spelling said. "He was so cute." The couple, who met when she costarred with him in a play he cowrote, *Maybe Baby, It's You,* exchanged self-written vows in a combined Jewish and Christian ceremony, and strolled down the aisle to the tune "I Got You Babe." Guests, including old friends from her Hollywood childhood, Jackie Collins, Bob Newhart and Paul Anka, among others, adjourned to a tent, where they enjoyed fantastical cuisine by Wolfgang Puck and songs from *The Great Gatsby* film soundtrack by surprise guest Michael Feinstein. By the end of the day, the bride still hadn't touched down. "It hasn't quite sunk in yet," she said. "I'm married! I'm a grown-up now."

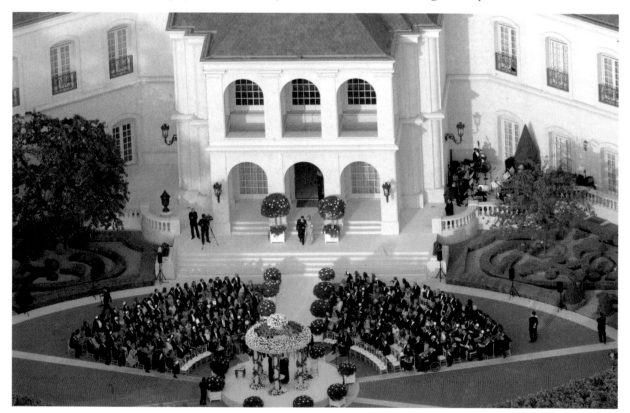

BACKYARD PARTY The couple wed under a floral chuppah. "When I host parties, I usually never have a good time because I'm always worried," Spelling told a reporter. "But I had a great time at my wedding. It was pure perfection."

kevin costner & christine baumgartner

SEPTEMBER 25, 2004 With a four-day extravaganza as big as Colorado, Costner, 49, introduced budding handbag designer Baumgartner, 30, whom he met on a golf course in 1993, to life in the wow lane. For two days beforehand, Bruce Willis, Tim Allen, *Dances with Wolves* costar Mary McDonnell and 320 guests played baseball on a new diamond, participated in a mini rodeo and chowed down on cowboy barbecue on the actor's 165-acre Aspen spread. "It was intimate, very romantic," said an attendee. "They're madly in love, and it showed." The reception kept the energy flowing, featuring stand-up by Allen, country music by Clay Walker and a dessert buffet of chocolate-dipped fruit and Oreos. "When they left," said Baumgartner, "it felt like the last day of summer camp."

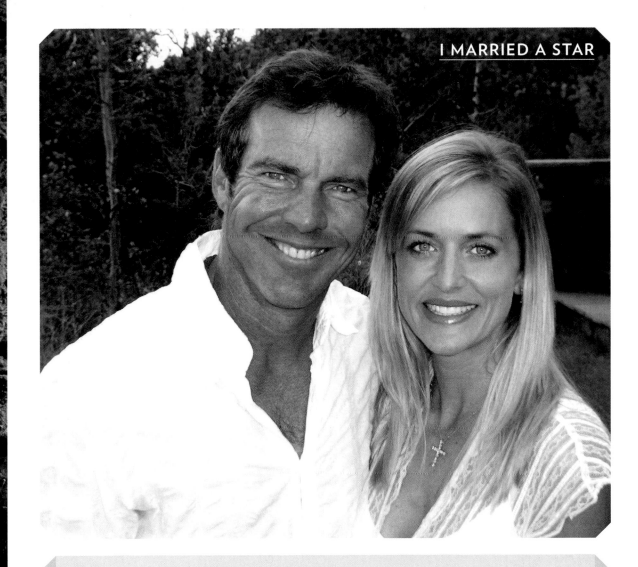

dennis quaid & kimberly buffington

JULY 4, 2004 Location, location, location was the order for Independence Day when the 50-year-old actor wed Austin, Texas, real estate agent Buffington, 32. The couple—she in white lace holding flowers he handpicked—exchanged self-written vows in "God's cathedral," as put by pal Jamie James, who also plays alongside Quaid in his band, the Sharks. In this case, that cathedral was a hilltop on Quaid's 500-acre Montana spread with a spectacular view of the Rocky Mountains. There were 15 guests—10 humans and the actor's five dogs. Jack, Quaid's 12-year-old son with Meg Ryan, served as best man. The nuptial day concluded with dinner at Quaid's ranch house followed by fireworks, which were hardly the first of the event. After all, the bride, who met Quaid through a mutual friend in 2003 when the Sharks played Austin, sported a sparkling platinum-and-diamond wedding band, which joined her eye-popping three-carat trilliant-cut canary diamond engagement ring. The actor bought the dazzling stone in Africa while filming *Flight of the Phoenix*. When he returned, he and Buffington met with longtime friends and jewelry designers Anthony Camargo and David Nakard Armstrong and asked them to turn the rock into the perfect ring. Said Camargo: "It is very unique and special, so we said, 'Let's glorify it.'" If that weren't incendiary enough, the wedding kiss after the midday ceremony "lasted until sunset," said James. "I was so happy for Dennis. It was amazing." And "everyone cried—even the dogs."

jason priestley & naomi lowde

MAY 14, 2005 Both Priestley, 35, and English makeup artist Naomi Lowde waved off the idea of a wedding planner. "Why should I let someone else screw up what I can do in my sleep?" joked the actor to the *Vancouver Sun*. The couple, who met by chance outside a London theater four years earlier, did a fine job by themselves. Priestley, whose first marriage ended in 1999, said they wanted a day that would be "classic but also modern." But when it came to one very important element, he stuck with the tried-and-true traditional wisdom for grooms-to-be. "When it comes to a woman and her wedding, you just have to let her do her thing," said the former TV star.

For her part, the bride, who chose a gown by Rani from St. Pucchi Couture and wore Neil Lane jewelry with an 18th-century feel, was aiming for a ceremony that would be "beautiful and honest and very true to our hearts." Both got their wish when they exchanged traditional, nondenominational vows at the One&Only Ocean Club on Paradise Island in the Bahamas. Music by the Royal Bahamian Police Marching Band had the approximately 120 guests, including *Beverly Hills, 90210* alums Tori Spelling, Tiffani Thiessen and Jennie Garth, tapping their feet. Less martial sounds at the reception were provided by the Canadian band Barenaked Ladies, pals of the groom. The wedding feast was old-fashioned: lobster and steak. While Lowde planned most of the day's details, Priestley had one last surprise for her up his Hugo Boss sleeve: a late-night fireworks display over the ocean.

PROPOSALS

HOW THEY POPPED THE QUESTION—AND GOT JUST THE ANSWER THEY HOPED FOR

◆ **Garth Brooks**, 43, proposed to **Trisha Yearwood**, 40, in front of 7,000 fans at Buck Owens's Crystal Palace in Bakersfield, California.

◆ **Nick Lachey**, 28, asked for the hand of **Jessica Simpson**, 21, on a yacht off the coast of Hawaii.

◆ **Rod Stewart**, 60, got on bended knee for **Penny Lancaster**, 34, at the Jules Verne restaurant at the Eiffel Tower in Paris. A few months later **Tom Cruise**, 42, proposed to **Katie Holmes**, 26, at the same location.

◆ **Seal**, 41, surprised **Heidi Klum**, 31, in Whistler, British Columbia, in an igloo built for the occasion at 14,000 feet.

◆ **Tom Arnold**, 43, proposed to **Shelby Roos**, 30, a political consultant, on his show *The Best Damn Sports Show Period*.

◆ **Chad Michael Murray**, 22, proposed to his *One Tree Hill* costar **Sophia Bush**, 21, on a tennis court in Australia adorned with 20 bouquets of roses and 500 lit candles spelling out a message.

◆ **Nick Offerman**, 31, and *Will & Grace's* **Megan Mullally**, 43, got engaged in a London park.

◆ **Tiger Woods**, 27, posed the question to **Elin Nordegren**, 23, at the Shamwari Game Reserve in South Africa.

◆ **Cheryl Hines**, 37, costar of HBO's *Curb Your Enthusiasm*, was proposed to by talent manager **Paul Young**, 33, on the 18th green.

◆ **Scott Wolf**, 35, of *Everwood*, presented **Kelley Limp**, 26, formerly of *The Real World: New Orleans*, with a 2.7-carat diamond ring over a sunset dinner after taking her on a boat ride to a cove on St. Barts.

MATCHMAKERS

Spouses **Diane Lane** and **Josh Brolin** met nine years earlier and were reintroduced by **Barbra Streisand**, Brolin's stepmother.

◆

Actor **Lou Diamond Phillips** takes credit for the gem of a romance sparked between **Matt LeBlanc** and **Melissa McKnight**, whom he introduced to each other.

◆

Brad Pitt and **Jennifer Aniston**'s managers linked up the A-listers in hopes that the two would become more than friends.

◆

Actress **Mariska Hargitay** brought love and order to the hearts of her friend **Bobby Flay** and her costar **Stephanie March**.

◆

Richard Gere was introduced to **Carey Lowell** by **Sharon Simonaire**, an interior designer, at a Manhattan restaurant in late 1995.

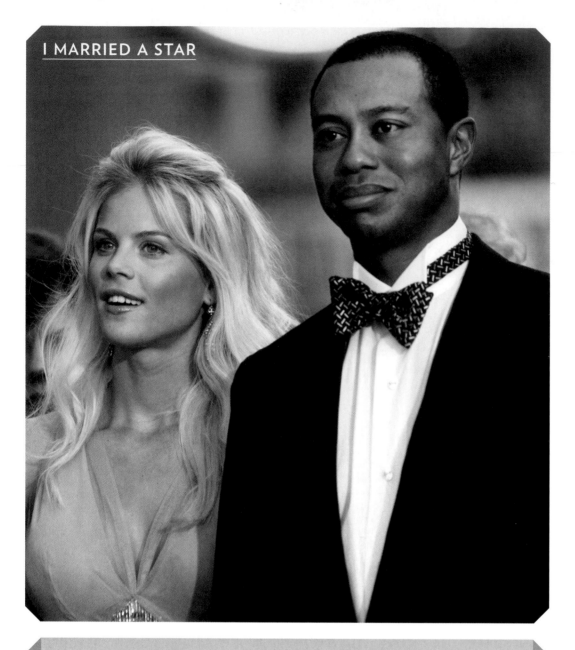

tiger woods & elin nordegren

OCTOBER 5, 2004 Keeping cool under tournament pressure has made him a winner. As for getting hitched? Par for the course. "He didn't act like he was going to get married," said a guest. "He was very relaxed, like this was any other day to him." The reason may have been that Woods, 28, was introduced to Nordegren, 24, at a links event, the 2001 British Open, when she was a nanny for fellow golfer Jesper Parnevik. "They're a perfect match," said Parnevik. Also, the couple were marrying on one of the Caribbean's best golf courses—with armed security guards keeping spectators at bay. At dusk in the exclusive Sandy Lane resort in Barbados, they said their vows amidst 500 red roses, which Woods had flown in for the big day, and surrounded by 200 family members and friends, including basketball greats Michael Jordan and Charles Barkley. The bride wore a Vera Wang gown. Later they dined on flying fish, macaroni pie and a four-tier wedding cake. Fireworks lit up the scene while Hootie & the Blowfish entertained. For Woods, it was a day without sand traps or shots in the rough. He told an interviewer, "We had a great time."

matt leblanc & melissa mcknight

MAY 3, 2003 To say I do to model McKnight, 38, his fiancée of five years, 35-year-old LeBlanc went Hawaiian. *Friends* castmates Courteney Cox, Jennifer Aniston and Lisa Kudrow joined the 75 guests bronzing on a Kauai beach for a couple of days (David Schwimmer and Matthew Perry couldn't attend because of theater commitments). At the sunset ceremony on an oceanside bluff, the focus was more on fun than formality. McKnight wore an off-the-rack gown, and LeBlanc didn't quite get his shirt entirely buttoned. McKnight's daughter Jacquelyn, 8, and son Tyler, 12, were dressed to match bride and groom. After the 25-minute ceremony featuring vows they wrote themselves, champagne flowed, island delicacies were consumed and hula and fire dancers wowed the crowd. "Everyone," said a friend, "was completely blown away."

liv tyler & royston langdon

MARCH 25, 2003 When people say weddings are all about family, they must be talking about Tyler, 25, and rock singer Langdon, 30. Engaged for two years, the pair tried to schedule their nuptials around the touring calendars of the *Lord of the Rings* star's relations. Her father is Aerosmith frontman Steven Tyler. Her mother, Bebe Buell, is married to musician James Wallerstein of Vacationland. And Buell's former life partner, rocker Todd Rundgren, helped raise Liv. The solution? Two ceremonies. The first, in March, was an intimate candlelit affair at a Barbados beach house attended by a few Langdon relatives. The second, including the bride's family, was held a month later in Manhattan. "It was an incredible experience because my mother, Todd and Steven had never been in a room together before, and Todd and Steven had never met," Tyler told IN STYLE. "In the end it was beautiful and a nice healing moment for all of our families."

leah remini & angelo pagan

JULY 19, 2003 "It was outdoors at night and still 110 degrees," said the bride's *King of Queens* costar Kevin James. "The best part was toweling off." Remini, 33, and actor-musician Pagan, 45, melted in each other's arms at their poolside ceremony at Las Vegas's Four Seasons Hotel. "I don't like weddings," the bride, known for her forthright wit, told an interviewer. "They're boring." Funny how the perfect dress can make such an impression. "We were going to elope, but as soon as I put the dress on, it was like, 'I am going to have a wedding.'" Remini's two-piece Les Habitudes ensemble included a duchesse satin bustier with silver beads and ivory pearls, and an organza skirt consisting of five layers. The couple's self-written vows, recited before a minister from the bride's Scientology center, "were very funny and very heartfelt," *King* director Rob Schiller told a reporter. "It brought tears to everybody's eyes." Pagan, who has three sons from previous relationships, "credited Leah with making him a better father," said Schiller. Remini, who fell for her sweetheart when the two danced salsa together at a Hollywood nightclub, "credited him with giving her some soul." Post-ceremony, the newlyweds and their guests, including actress Jenna Elfman, headed into a white tent strewn with love seats. Joked Remini: "It looked like a P. Diddy party." Event planner Mindy Weiss arranged a dinner that embraced the pair's Italian, Jewish and Puerto Rican heritage. Afterward: dancing and the cooling pleasures of a martini bar and a sno-cone machine.

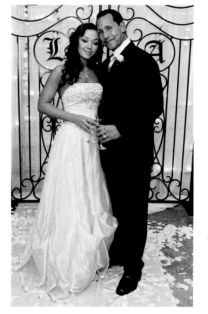

PRINCESS LEAH
Above, the bride and groom toast to an out-of-this-world love. Below, a private moment.

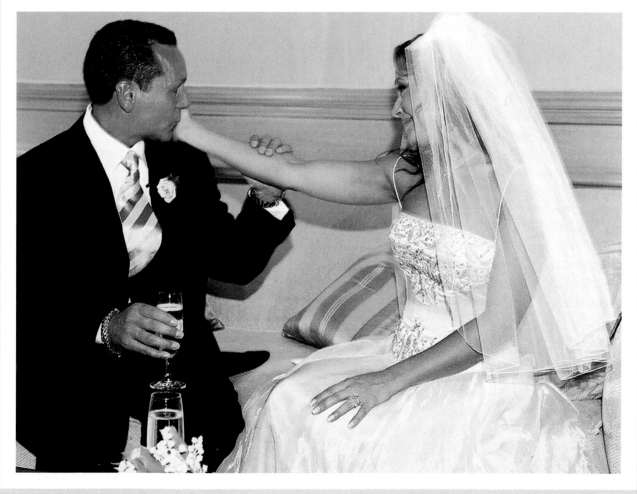

QUEEN for A DAY

Regal looks lead the way coming down the aisle

STEFFIANA DE LA CRUZ

Married Kevin James in a strapless Tomasina gown with beaded and embroidered trim.

ALICIA RICKTER

Married the Mets' Mike Piazza in a Vera Wang satin dress with silver sequin accents.

TORI SPELLING

Married Charlie Shanian in a crystal-beaded Chantilly lace Badgley Mischka gown.

HETHER SIMPLE OR SUBLIME, the visions of celebrity brides are being brought to life by top designers. Tori Spelling sketched and Badgley Mischka delivered with her crystal-beaded Chantilly lace gown. Jessica Simpson's crystal-and-pearl-adorned ballgown was created by the ubiquitous and revered Vera Wang—as were Liza Huber's alençon lace gown, Alicia Rickter's satin siren gown and, reportedly, two dresses for Jennifer Lopez's postponed nuptials with Ben Affleck. A fitted strapless gown by Monique Lhuillier, another A-list favorite, made the cut for Britney Spears's under-the-radar ceremony. But tradition has many faces, such as Salman Rushdie's betrothed, Padma Lakshmi, who wore a midriff-bearing purple sari for the ceremony (white is the color of widowhood in her native India) and changed into a Luca Luca ensemble for the reception. Some brides go to great lengths for the perfect dress. For Mrs. Trump, Melania Knauss, that meant trips to Europe's haute couture fashion shows to ultimately decide on the Christian Dior Haute Couture gown, custom-made in Paris from 90 meters of satin by 28 seamstresses who spent more than 1,000 hours on the project. At the price of a home, that's bridal bespoke.

MELANIA KNAUSS

Married Donald Trump in a Christian Dior hand-beaded and embroidered white satin gown.

PADMA LAKSHMI

Married Salman Rushdie in a purple sari but changed to this Luca Luca ensemble.

KING JAMES
The King of Queens' Kevin James sweeps his princess bride, Steffiana de la Cruz, off her feet in a suite at Laguna Beach, California's Montage Resort and Spa, June 19, 2004.

ACTORS in LOVE

These scene-stealers decided to costar as man
and wife after the credits rolled

dulé hill & nicole lyn

JULY 10, 2004 The wedding venue was no problem, mon. Both *The West Wing*'s Hill, 29, and *Deliver Us from Eva*'s Lyn, 26, are of Jamaican descent. The two first met in 1997 at a New York City hotel lounge after Hill's performance in the Broadway hit *Bring in 'Da Noise, Bring in 'Da Funk*, but didn't get together until 2000, when they bumped into each other again at a "Jamerican" arts festival in L.A. Cupid couldn't have framed it better. "I definitely wanted my wife to be Jamaican," Hill told an interviewer. "And even before we met I knew I wanted to get married in Jamaica, and so did she. Our roots are there." The affair at Montego Bay's Round Hill resort was especially family-friendly. The actress was escorted to the altar with her father on one arm and her stepfather on the other, wearing a halter-style silk chiffon slip dress created for her by Pamela Dennis. "When Dulé saw Nicole coming down the aisle, he completely welled up," a guest said. "We all started bawling." Hill's nephew Julien and Lyn's cousin Sidney were in the wedding party, and the groom's grandfather, Rev. Berris A. Hill, officiated. Hill's dad concocted enough traditional Jamaican-rum punch to satisfy all 300 guests. After dining on grilled seafood, pepper pot soup and a rum and brandy Jamaican wedding cake, the couple hit the dance floor to a tune that summed up the day: Luther Vandross and Gregory Hines's "There's Nothing Better Than Love." Parting gifts for the guests also had an island flavor: "Dulé made a mix CD of his favorite reggae love songs," said Lyn. *Irie*!

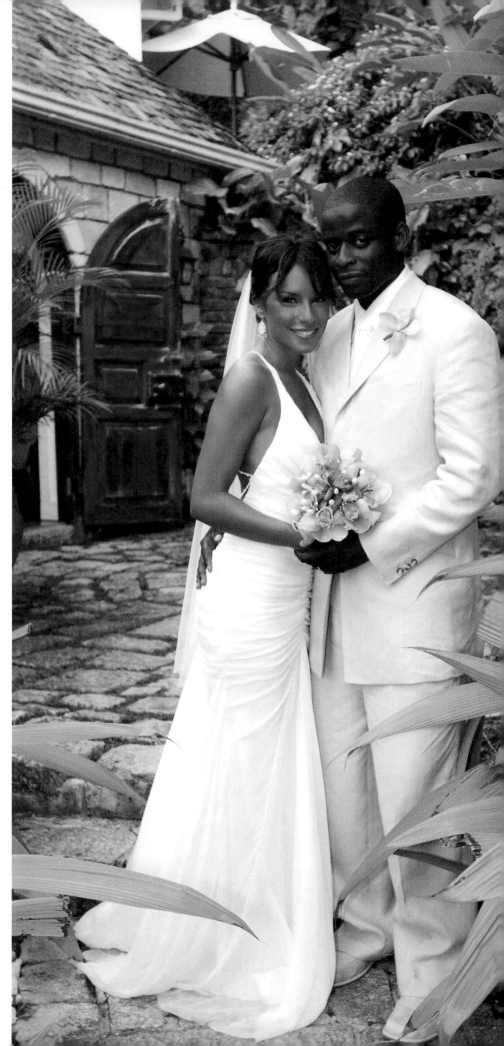

Lyn, with brides-
maids, whose
pastel and floral
dresses were
island-influenced.

Event planner
Frances Mais of F.R.
Mais Limited used
birds-of-paradise
as table decor.

Suspended lamps
lit up the
Caribbean night.

Hill's dog tags,
engraved with his
wedding date .

sarah michelle gellar & freddie prinze jr.

SEPTEMBER 1, 2002 As Buffy the Vampire Slayer, Gellar, 25, tamed more than her fair share of monsters, but she couldn't get Mother Nature to behave at her Mexican nuptials as storms forced it indoors. Nothing, however, could dampen the spirits of the *Scooby-Doo* costars and their wedding posse. The 60 guests, including Shannen Doherty, *The West Wing*'s Dulé Hill and Wilmer Valderrama (*That '70s Show*), partied and primped at the remote El Careyes resort for four days. "It was the most incredible weekend," said actress-bridesmaid Lindsay Sloane (*Bring It On*). "We laughed, danced and shared in their love." The pair, who met on the set of 1997's *I Know What You Did Last Summer* and fell in love three years later, exchanged platinum wedding bands by L.A. designer Cathy Waterman be___film director pal Adam Shankman (*A Walk to Remember*), who got himself ordained over the Internet so he could officiate at the cliff-top villa. "They glowed as they gazed at one another," said a guest. "Everyone could feel the love they were sharing. It was perfect." With I dos out of the way, the bride traded the heels she wore with her ivory silk tulle Vera Wang A-line for flip-flops. After a supper of filet mignon, lobster tails, champagne and mojitos, Gellar, who calls her husband "My first love," and Prinze, 26, who calls her "My girl," took their first wedded spin to "Someone to Watch Over Me." The groom's mother, Kathy, spo___ or everyone when she pronounced, "They're quite the couple."

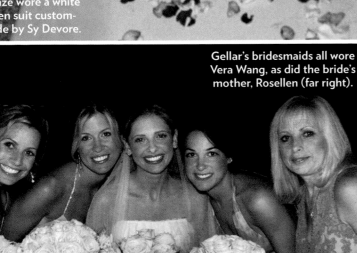

PRINZE AND PRINCESS
Gellar donned a Vera Wang silk tulle strapless A-line dress with hand-pleated ruffles and a sweeping train. Prinze wore a white linen suit custommade by Sy Devore.

Gellar's bridesmaids all wore Vera Wang, as did the bride's mother, Rosellen (far right).

BRIDES ON THE BEACH

STARS CHOOSE THE UNTRADITIONAL IN VENUES AND GARB

◆ **Renée Zellweger** and **Kenny Chesney** married on St. John in the Virgin Islands. She wore a Carolina Herrera gown, and he wore a black cowboy hat.

◆ **Michelle Branch** wore flip-flops with her Morgane Le Fay gown when she wed on a remote island off the Mexican coast. The groom, **Teddy Landau**, wore swim trunks and a dress shirt.

◆ **Jack White** and **Karen Elson** married in a canoe at a junction of three rivers in the Amazon in Brazil before a shaman.

◆ **Taye Diggs** and **Idina Menzel** wed at Round Hill Hotel in Jamaica, where Taye filmed *How Stella Got Her Groove Back.*

◆ **Diane Lane** and bridesmaid Elizabeth Perkins walked down the aisle barefoot on groom **Josh Brolin**'s L.A. ranch.

◆ **Wynonna Judd** held her reception at one of the largest log cabins in the U.S., built by Barbara Mandrell in Tennessee.

◆ **Jill Whelan**, 37, who played Vicki Stubing on *The Love Boat,* and **Michael Chaykowsky**, 41, a school operations director, wed aboard a cruise ship. Castmates Gavin MacLeod and Bernie Kopell were guests. It was broadcast live on the Internet.

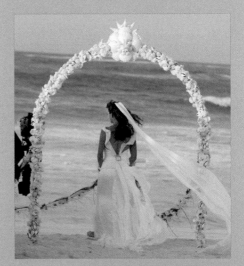

PARADISE Amber Brkich wed Rob Mariano on the beach in the Bahamas.

the PRINCESS BRIDE

Ladies of the day shine brilliantly in jewels fit for a royal wedding

GLITTERING GWEN
Stefani wore this Neil Lane Georgian heart pendant at her Los Angeles wedding.

FROM VINTAGE-INSPIRED PIECES TO GEMS WITH A modern twist, wedding-day sparklers that make a dazzling statement akin to the crown jewels are the new choice of stars. With the renaissance of tiaras, Hollywood brides from Kate Beckinsale to Madonna and Britney Spears seem to be having a case of royalty envy. Although Jennifer Lopez didn't wear one, she let her gems do the talking at her backyard affair—wearing more than 300 carats in necklaces, bracelets, earrings and hairpins, worth $7 million, all by Neil Lane. At Gwen Stefani's second ceremony (the first was in London), she wore the same wedding dress but added Lane's pendant of pink tourmaline, peridot and diamonds set in silver and gold. "I think she saved it to make a special statement for her wedding at home in Los Angeles," said Lane, whose pieces also adorned Carmen Electra, Tori Spelling and Christine Costner. Lopez's engagement rock from ex Affleck fueled a zeal for ever-bigger stones. The Bennifer ring was trumped when Melania Knauss received her $1.5-million Graff stunner, paired with an Edwardian necklace borrowed from Fred Leighton for their opulent affair. Soon, for gem watchers, there will be Paris.

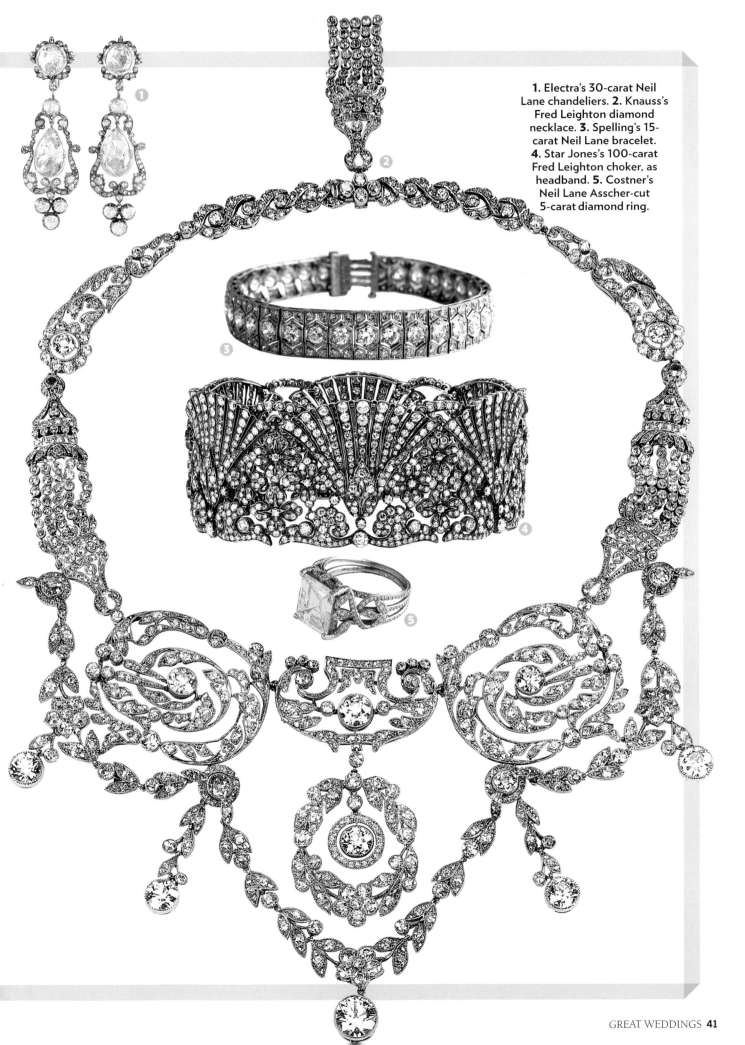

1. Electra's 30-carat Neil Lane chandeliers. 2. Knauss's Fred Leighton diamond necklace. 3. Spelling's 15-carat Neil Lane bracelet. 4. Star Jones's 100-carat Fred Leighton choker, as headband. 5. Costner's Neil Lane Asscher-cut 5-carat diamond ring.

1. Knauss's 13-carat flawless diamond from Graff. 2. Jackie Titone's pierced platinum, diamond and pearl Neil Lane bracelet. 3. Kevin Federline codesigned this Lizzie Scheck infinity necklace with baby pink pearls for Britney.

THE ROCKS THAT SHE'S GOT For her wedding ceremony with Marc Anthony, Lopez wore Neil Lane's platinum-and-diamond

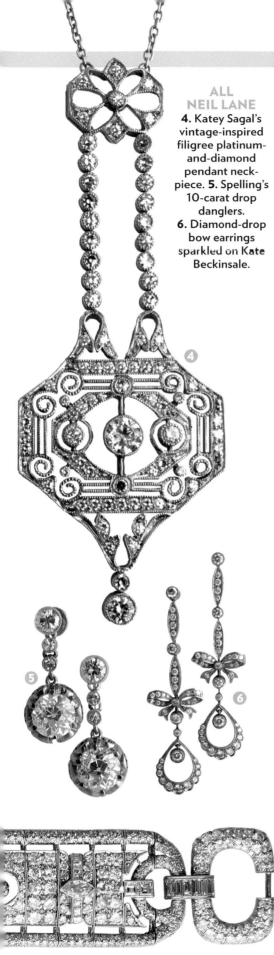

ALL NEIL LANE
4. Katey Sagal's vintage-inspired filigree platinum-and-diamond pendant neckpiece. **5.** Spelling's 10-carat drop danglers. **6.** Diamond-drop bow earrings sparkled on Kate Beckinsale.

art deco bracelet (above) and S hair clips (left).

CIRCLE OF LOVE

WHETHER SUBLIME OR SUBDUED, THESE ENGAGEMENT GEMS REFLECT THE PERSONALITIES OF THE STARS WHO WEAR THEM

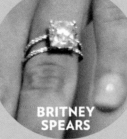

BRITNEY SPEARS

Spears chose Cynthia Wolff's 4-carat cushion-cut diamond set on two slim platinum bands with micropavé diamonds.

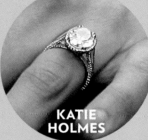

KATIE HOLMES

Holmes's couch-jumping-worthy Edwardian-style oval-shaped diamond ring of about 5 carats in a pavé setting.

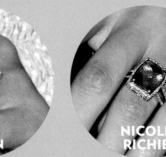

PARIS HILTON

Hilton test-drove two rings at clubs and asked friends to help her choose. For now, the 24-carat yellow diamond wins.

NICOLE RICHIE

Deejay Adam Goldstein gave Richie, his girlfriend of one year, this pink sapphire stunner, which is her birthstone.

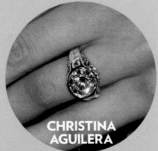

CHRISTINA AGUILERA

"It's classic, but has a rock and roll feeling," said Aguilera of her 5-carat diamond-and-platinum Stephen Webster ring.

JENNIFER GARNER

Secret ceremonies call for subdued sparkles: Garner sports an elegant eternity band with round diamonds.

mariska hargitay & peter hermann

AUGUST 28, 2004 The locales on *Law & Order: Special Victims Unit* tend to the gritty and depressing. So the nuptials of *SVU*'s Hargitay, 40, and Hermann, 37, who had a recurring role on the show, provided the actors with a breath of fresh— and luxe—air. A gospel choir sang the newlyweds out of Santa Barbara, California's lovely Unitarian Historical Chapel with a rousing "Ain't No Mountain High Enough." For the reception, 200 guests, including Jodie Foster, Hilary Swank and Joely Fisher, entered an enchanted forest theme by planner Yifat Oren at a nearby estate, which featured a swan pond surrounded by rose petals. The day, said Oren, "was magical. They're mad about each other. And they're hilariously funny together."

benjamin bratt & talisa soto

APRIL 13, 2002 Moms and mum were the words when actor Benjamin Bratt, 38, wed Puerto Rican actress Talisa Soto, 35, in a private ceremony officiated by his mother, Eldy, who is deputized to perform civil marriages. Soto's mother, Clari, walked her down the aisle to Peruvian flute music (a nod to Bratt's heritage). Twenty loved ones watched the bride, wearing an off-the-rack satin-chiffon dress with flip-flops, and groom, wearing a black Calvin Klein suit, exchange self-written vows on a San Francisco hillside. The pair met on the set of the 2001 film *Piñero*. "It's like being in love for the first time," Bratt told reporters in March 2002, a month after he secretly proposed. A Soto pal said the former model was full of "excitement about their future." On December 6, 2002, that future included daughter Sophia.

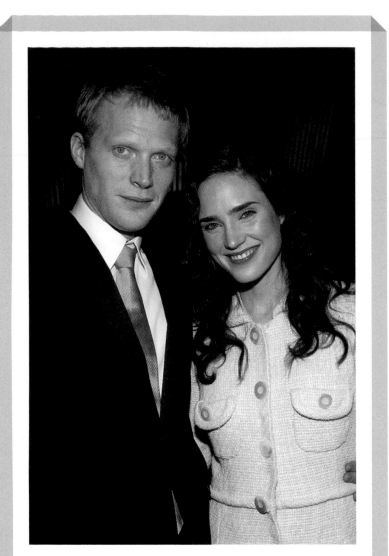

boris kodjoe & nicole parker

MAY 21, 2005 Call it destiny that a couple who met while taping Showtime's *Soul Food* would have a pre-wedding day celebration that included a ritual of smashing dishes. Such was the case when actress Nicole Ari Parker, 34, wed actor Boris Kodjoe, 32, in Kodjoe's hometown of Gundelfingen, in Germany's Black Forest. "I broke a basketful of plates," Parker said of the traditional German Polterabend. On their wedding day, the couple married at the church where Kodjoe was baptized. At the reception, 1,200 candles lit the garden of his childhood home, and dessert included a linzer torte baked by his 87-year-old grandmother. In on the family fun: the couple's 3-month-old daughter Sophie Tei-Naaki Lee.

LOVE, GERMAN-STYLE "It was what I dreamed of," says Parker, who wore a cotton dress by Belgian designer Kaat Tilly. At bottom, the backyard reception held at Kodjoe's home in Gundelfingen.

jennifer connelly & paul bettany

JANUARY 1, 2003 Holding a "low-key" Hollywood wedding can merely mean cutting the guest list down by a few hundred. But Connelly, 32, and London-born Bettany, 31 (*A Knight's Tale*), really meant it. Only 14 family and friends were invited to their union at an out-of-the-way Scottish manor house on New Year's Day. To ensure serenity, the Brooklyn-raised actress's parents rented all 1,000 acres of Gilmerton House, an estate near Edinburgh. Wed in a candlelit music room, bride and groom wore matching black for a ceremony conducted by a local minister. It was a first marriage for both, although Connelly's 5-year-old son Kai, with New York City photographer David Dugan, attended. The pair, who met on the set of 2001's *A Beautiful Mind,* for which the actress snagged an Oscar, had a relaxed relationship from the beginning. "It was nice in that it didn't feel like a courtship," she said in an '03 interview. "It was much more comfortable than that." Overall, said Bettany's father, Thane, an actor, "Jennifer was delighted at the idea of a Scottish wedding. We had a wonderful time. It was really a family celebration."

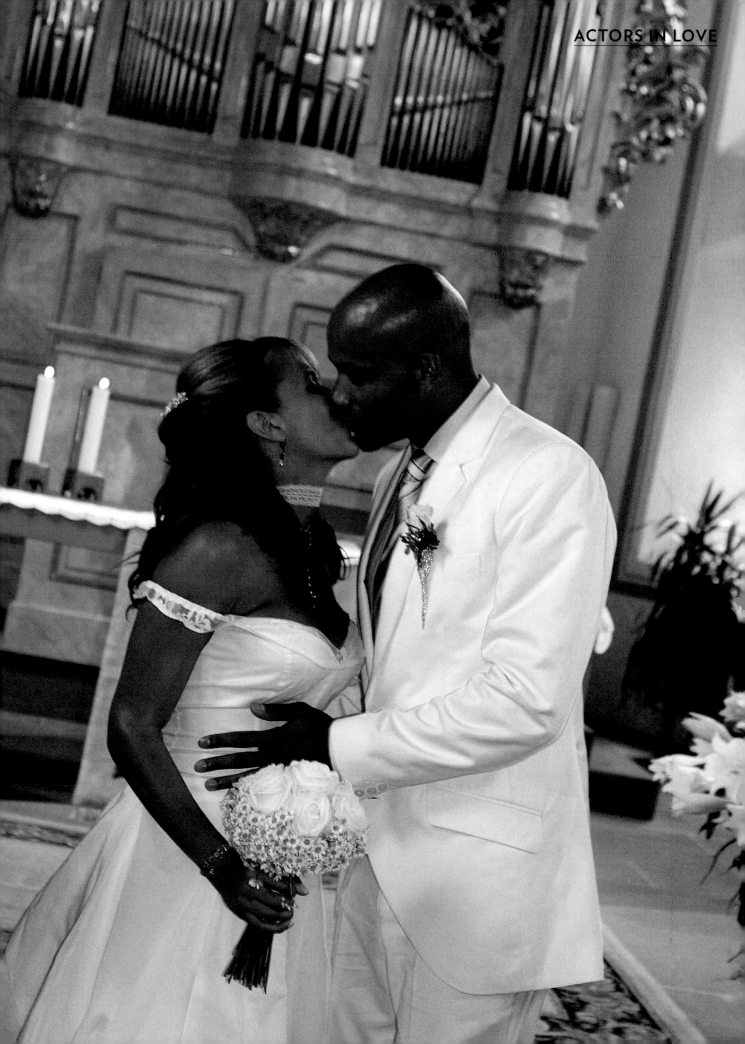

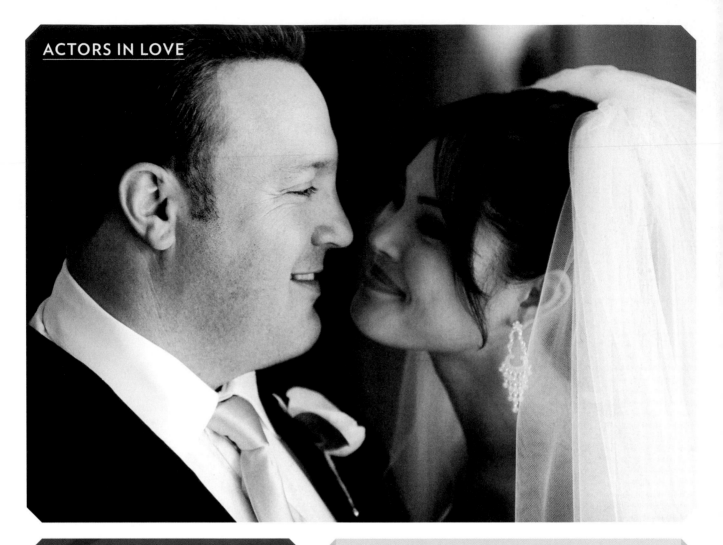

A four-tier cake by L.A.'s Fantasy Frostings layered with boxes of flowers.

kevin james & steffiana de la cruz

JUNE 19, 2004 *The King of Queens'* Doug Heffernan is just a regular working stiff, so it seems only right that the guy who plays him had Big Macs at his wedding. James, 39, didn't start off in drive-thru mode. When he joined model-actress de la Cruz, 29, his longtime girlfriend whom he met on a blind date, at St. Edward the Confessor Catholic Church in Dana Point, California, he "was very nervous," said an attendee. "He was sweating." James relaxed after swapping vows with his bride (who wore a Tomasina gown) in front of 180 guests, including Clint Eastwood, Ray Romano, Jerry Stiller and Lou Ferrigno. Planner Mindy Weiss followed the couple's wishes for a laid-back party. She filled the ballroom at Laguna Beach's Montage Resort and Spa with comfy couches and nary a dining table in sight. And forget the goody bags. While Eddie Money played, guests gathered at casino tables to vie for prizes such as a plasma TV and a Palm Pilot. The buffet ran the gourmet gamut from sushi for Madame to fast food for Sir. They wanted "all kinds of food," said Weiss. "Even McDonald's."

chad michael murray & sophia bush

APRIL 16, 2005 On The WB's teen drama *One Tree Hill,* the characters Lucas and Brooke are on-again-off-again lovers. Their real-life counterparts, however, are inseparable. Costars Murray, 23, and Bush, 22, who met on the *Hill* set in '03, sealed their devotion with an emotional union worthy of a TV show. Both the bride, in Vera Wang, and the groom, in Ralph Lauren Black Label, choked up at the altar. "Chad was crying like a baby," said a guest. "Sophia cried too." The couple managed to get through their handwritten vows on the beach at Santa Monica's Hotel Casa Del Mar to cut the groom's chocolate tribute to his hometown Buffalo Bills, then hit the floor to slow-dance away from the crowd. Said the bride's mother: "They are both very romantic."

russell crowe &
danielle spencer

APRIL 7, 2003 As befits a master and commander, the Aussie actor planned his wedding with precision. Nearly 100 guests, including *Gladiator* director Ridley Scott, spent four days of fun and games at Crowe's 560-acre cattle ranch in Nana Glen, Australia. He scheduled the event for his 39th birthday, and even timed the bride's motorcade so that the 32-year-old *Down Under* TV star, his longtime love, would arrive exactly at sunset. But the discipline—and the groom—broke down a bit during the Anglican ceremony in the circular chapel on the ranch. "He started choking up," said pal John McGrath. "He's a rugged sort of guy, but he's also got a very soft center." Elton John, Catherine Zeta-Jones and President Bush sent their congratulations. "The whole thing was pretty special," Crowe told a reporter. "And I'm not saying that just to pat myself on the back."

adam sandler & jackie titone

JUNE 22, 2003 There wasn't a damp eye in the house when the 36-year-old comic wed model-actress Titone, 28. Smiles, not sentiments, predominated at the traditional Jewish ceremony on Dick Clark's oceanfront Malibu estate. Jennifer Aniston, Winona Ryder, Chris Rock and Dustin Hoffman, along with the rest of the 400 guests, cracked up when the groom's bulldog Meatball, swaddled in tux and yarmulke like his master, trotted down the aisle with a ring pillow strapped to his back. Titone, who had roles in 1999's *Big Daddy* and four of Sandler's subsequent comedies, responded with a joke of her own. Her gift to her husband—Matzoball, a bulldog puppy—arrived in a flower-decked wagon. The bride, in a Carolina Herrera gown with a draped bodice and spaghetti straps, and Sandler, in Armani, played it straight beneath an elaborate floral chuppah built of tree branches but couldn't sustain the solemnity. The reception featured a Wolfgang Puck deli menu of pastrami, corned beef and matzo ball soup as a nod to his Brooklyn roots. The groom's cake resembled two dog bowls, replete with confectionary kibble. For a big finish, Sandler reprised his *Wedding Singer* role, serenading his bride with lyrics about her. "The best part of the day was when Adam sang to me," Titone told a reporter. "It made me laugh and cry." Guest Rodney Dangerfield had his own take: "It was a real classy affair. Only two fights broke out, and I made $12 parking cars." The groom made a posting of his own on his Web site: "Sandler got married. . . . Woopity Doo!"

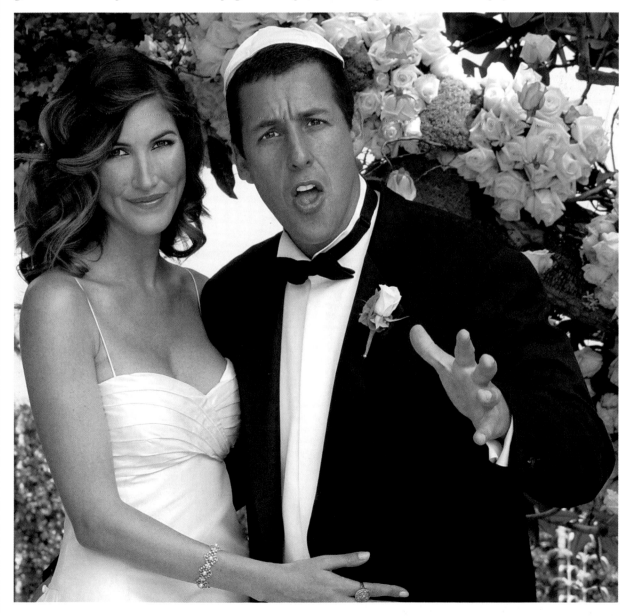

WEDDING

IS IT SOMETHING IN THE WATER? ON THE SNACK TABLE? OR JUST A

LAW & ORDER: SVU

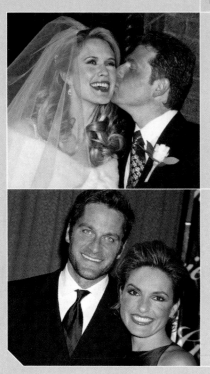

STEPHANIE MARCH & BOBBY FLAY She loves to eat but hates to cook. So when Flay, 40, a celebrity chef, wanted to persuade *Law & Order: Special Victims Unit*'s March, 30, to go out with him, it was a hard-to-get dinner reservation that won him the shot. And on February 20, 2005, after a four-year courtship that sparked when March's costar Mariska Hargitay played matchmaker, Flay scored again with a wedding at St. Peter's Episcopal Church in N.Y.C.

MARISKA HARGITAY & PETER HERMANN When the actors met on the set of *Law & Order: SVU* in 2001, Hargitay, 40, tried to break the ice with a joke. "He didn't think I was funny," she told a writer. Months later, a serious chat about religion provided divine intervention. Hermann, 37, invited her to church, and when she saw him there, "I thought, 'That's my husband.'" The pair wed at Santa Barbara, California's Unitarian Historical Chapel on August 28, 2004.

THE SOPRANOS

JAMIE-LYNN SIGLER & A.J. DiSCALA Sopranos, altos and actors were among the guests at the stormy-day wedding of the actress and her manager groom. The event, which took place at New York's Brooklyn Botanic Garden on July 11, 2003, included well wishes from costars Edie Falco and Lorraine Bracco and entertainment by the legendary singer Carly Simon. The *Sopranos* bride, wearing Vera Wang, even joined in for a few songs.

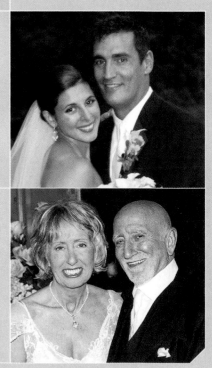

DOMINIC CHIANESE & JANE PITTSON Uncle Junior doesn't only belt Italian tunes on *The Sopranos*, he also does so in real life, and his wedding to Jane Pittson, 56, was no exception. Chianese, 72, serenaded his (fourth) bride and their 200 guests, including costar James Gandolfini, at Manhattan's posh Astor House. The honeymoon, however, was delayed as he promoted his album *Ungrateful Heart: The Ultimate Italian Collection*.

EPIDEMICS

WAVE OF ROMANCE AS SOME OF TV'S FAVORITE CASTS GET HITCHED

BUFFY THE VAMPIRE SLAYER

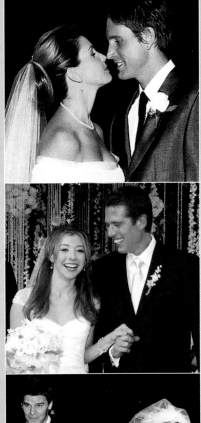

CHARISMA CARPENTER & DAMIAN HARDY Carpenter, 35, was set to marry Hardy, a psychology student, wearing her custom-made Vera Wang dress in 2003. But a little bundle of joy (the then-expecting couple's unborn son Donavan) had a different plan. The pair bumped up the date and hosted a small ceremony in Vegas with relatives on October 5, 2002. "Damian and I plan to remarry in the Catholic church on our fifth anniversary," said Carpenter, formerly of *Buffy* and *Angel*. "I can't let [the Vera Wang gown] go to waste."

ALYSON HANNIGAN & ALEXIS DENISOF When *Buffy*'s Hannigan, 29, married *Angel*'s Denisof, 38, they let the good times roll. Hannigan wanted a photo booth, and Denisof wanted a trampoline. Said planner Rob Smith: "They wanted pictures they could look back on 50 years from now." The couple wed October 11, 2003, at the Two Bunch Palms resort outside Palm Springs, California. And the flicks from the festivities were just what Hannigan had hoped for. "Those things I will look at and laugh at and treasure always," she said in an interview.

DAVID BOREANAZ & JAIME BERGMAN From first date to wedding day, *Buffy* and *Angel*'s Boreanaz and *Son of the Beach*'s Bergman embraced old-fashioned flair. When Boreanaz tenderly spoke about his family at dinner, Bergman said she knew he was "husband material." Boreanaz eventually proposed with a 1920s art deco diamond-and-platinum ring. And when the two wed in November 2001 at Palm Springs' Ingleside Inn (the honeymoon locale of Clark Gable and Carole Lombard), Boreanaz said Bergman was his modern-day Marilyn.

NICHOLAS BRENDON & TRESSA DI FIGLIA Sparks flew when friends introduced Brendon to Di Figlia in 1999. They bickered nonstop. Come their first date, Brendon was hooked, even telling Di Figlia's parents, "You know, I'm going to marry your daughter." In September 2001, he made good on his promise, and married the actress and writer at the family's ranch in Carlsbad, California. Brendon's *Buffy* costars Sarah Michelle Gellar, Alyson Hannigan and Alexis Denisof were among 250 guests helping to celebrate the happy ending.

DAWSON'S CREEK

KERR SMITH & HARMONI EVERETT The vibe at the June 7, 2003, nuptials of *Dawson's Creek's* Smith, 31, and his sweetie Everett, 28, fit perfectly. "We are so well suited for each other because both of us are very laid-back," Smith told a writer. Costar Katie Holmes, among 60 guests, came to the La Quinta Resort & Club near Palm Springs three days before the big day for a weekend of spa and BBQ. Said Smith: "People who did not know one another were getting along like they'd been friends for 20 years."

JAMES VAN DER BEEK & HEATHER McCOMB When Van Der Beek, a then-struggling actor, crashed at actress Jennifer McComb's (*Zoolander*) place after filming the *Dawson's Creek* pilot, he had no idea his life was about to change. Not only did he land a hit show; he also landed a wife—Jennifer's sister Heather (*Party of Five*). And after four years of dating and an 18-month engagement, the 26-year-olds wed July 5, 2003, at the Saddlerock Ranch in Malibu with 120 guests, including *Dawson's* alum Michelle Williams.

FRIENDS

MATT LeBLANC & MELISSA McKNIGHT LeBlanc proved that when it comes to class, he far exceeds Joey Tribbiani. For his May 3, 2003, nuptials to longtime girlfriend McKnight, LeBlanc hosted 75 loved ones, including his female *Friends* costars, on the island of Kauai for a weekend of mahimahi and matrimony. Guests agreed that the couple, who had been engaged for five years, made the ceremony, which included Hawaiian traditions, well worth the wait. Said actress Lisa Kudrow: "It was so romantic and beautiful."

COURTENEY COX & DAVID ARQUETTE The union of *Friends* star Cox and actor Arquette seemed unlikely to some. "David is the wild, crazy one," said an observer. But the two were a perfect match when they wed at Grace Cathedral in San Francisco on June 12, 1999, before 250 guests, including Cox's costars. "They looked like two little kids looking at each other," said a guest. And when he tried to put the ring on and it wouldn't fit, the groom did what any groom would do: He licked her finger. And it worked.

EPIDEMICS

BAYWATCH

GENA LEE NOLIN & CALE HULSE Three's company for *Baywatch*'s Nolin and hockey's Hulse. When they wed at Phoenix's Royal Palms resort in September '04, they incorporated Nolin's son Spencer, 7, who walked Mommy down the aisle and helped light the unity candle. He later joined them on their honeymoon. "It was always we, not Gena and I," Hulse told a reporter. Added Nolin: "All three of us were getting married. That was our theme."

YASMINE BLEETH & PAUL CERRITO JR. They met in a Malibu rehab clinic in December 2000. Nine months later they were busted for cocaine possession, which landed him in jail and her with two years' probation. But in the summer of 2002, love conquered quite a bit for *Baywatch* alum Bleeth, 34, and nightclub owner Cerrito, 32. The couple tied the knot at Santa Barbara, California's exclusive Bacara Resort and Spa overlooking the Pacific.

ALICIA RICKTER & MIKE PIAZZA Mets catcher Piazza hit a homer when he proposed to *Baywatch* beauty Rickter with a 5.3-carat diamond. The couple wed January 29, 2005, at St. Jude Catholic Church in Miami. Piazza joked that he had tried to impress Rickter, a baseball novice, with his home-run reel, which "left out the strikeouts." Now, when it comes to the pressures of the game, "she gets it," he told a writer. "And that's all I need."

ANGELICA BRIDGES & SHELDON SOURAY When a friend introduced *Baywatch*'s Bridges to the NHL's Souray, it was a pickup truck, not a pickup line, that hooked her. When she heard that the trucks were his fave too, "I thought, 'This is too good to be true. He's 6'4", gorgeous and drives a truck? Somebody pinch me,'" she told a reporter. Instead of pinching, Souray popped the question. The two united at Las Vegas's Bellagio hotel.

MICHAEL BERGIN & JOY TILK As fitting for a *Baywatch*er, actor and former model Bergin married makeup artist Tilk, the mother of his two children (Jesse, 5, and Alana, 7 months), September 24, 2004, before 23 guests at Kauai's Hanalei Bay Resort. The paradise affair brought tears to their eyes and curious questions from Jesse. He asked, "Mom, why are you crying?" said Bergin. "We had to tell him it wasn't sad tears, it was happy tears."

CHAPTER 4

LOVE
at WORK

Whether on-set, on tour or during the interview,
these couples met for professional reasons and bonded for
life when the job was done

the edge & morleigh steinberg

JUNE 22, 2002 The U2 guitarist and the choreographer met when they worked together 13 years ago (she danced with the band on the '92-'93 tour) and had two children before they made it legal at a Dublin registry office. Four days later, on a sun-splashed day at the ruins of a medieval castle in the village of Eze on the Côte d'Azur, the Edge (Dave Evans), 40, wearing his trademark wool cap, and Steinberg, 37, in a lace gown by Rozae Nichols, said their vows again before her father, Robert, an L.A. attorney. Referring to the bride's mantilla-style veil, record producer pal Howie B said, "She looked like a Spanish princess." After the ceremony, which featured vows the couple wrote themselves and both Christian and Jewish elements, the 250 guests, including Bono and the rest of U2, actor Dennis Hopper, singer Lenny Kravitz and models Helena Christensen and Christy Turlington, walked to a nearby garden of the Chêvre d'Or hotel for canapés and champagne. As evening fell, they headed over to LeRose, the seaside villa co-owned by the Edge and Bono, for a dinner of truffles, lamb and meringue. With the couple's two children, Sian, 4, and Levi, 2, on hand, as well as the three teenage girls from the Edge's first marriage, the main entertainment was an egg-and-spoon race. "You place a spoon in your hand and an egg on top and run like a mother," explained Howie B. Later on the dance floor, the guitarist and the dancer delighted onlookers with a tango before heading off on a honeymoon cruise. Another guest noted of the day, "It was much more of a family wedding than a showbiz do."

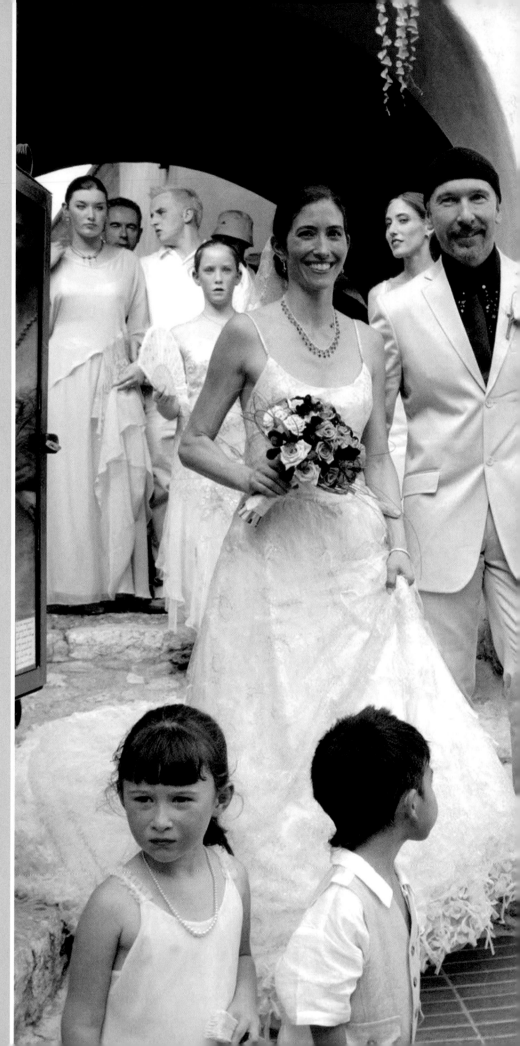

constance ramos
& j.j. carrell

MAY 6, 2005 On *Extreme Makeover: Home Edition,* cohost Ramos, 36, was used to tearing things up and rebuilding them. So it was in the nature of things when, a week before her nuptials with Border Patrol agent J.J. Carrell, also 36, the architect had to rip up and alter her wedding dress. "A lot of that stuff would freak out other women, but she rolls with it," said the groom. "That's one of the things I love so much about her." The two struck up a friendship on the set after Carrell's videotape successfully nominated a friend's place in Yorba Linda, California, as a subject on the ABC show. The relationship soon turned into a project that was a bit more intense. "Something came over me," said Ramos. "I said, 'I'm in love with that guy.'" Less than a year later, before 130 guests, including much of the *Makeover* cast, the pair said their vows at Saint Elizabeth Seton Catholic Church in Carlsbad, California. The event left the TV host bemused. "I think about destiny," she told *USA Today* of meeting Carrell. "And I don't think it was a coincidence."

pierce brosnan & keely shaye smith

AUGUST 4, 2001 The luck of the Irish? Not at first. Brosnan, 49, and Smith, 37, partners for seven years and parents of sons Dylan, 4, and Paris, 6 months, tried twice to get to the altar. The first postponement for the pair came when Brosnan's 16-year-old son Sean was injured in a car accident. (The actor also has two stepchildren—Christopher, 28, and Charlotte, 29—with his first wife, who died of cancer in 1991.) The second came when Smith, a former TV reporter who met the Bond man while on assignment, became pregnant with Paris. The baby also held things up on the big day. While the groom paced in Ballintubber Abbey, a 785-year-old church in Ireland, Smith had to get out of her Richard Tyler gown to breast-feed Paris. Said the proud papa to an interviewer: "We are a working family." Then Dylan made last-minute protests about wearing a tux and carrying the rings. (The youngster eventually compromised and donned the tux, instead of the Hawaiian shirt he favored, with his motorcycle boots.) After finally saying their traditional Catholic vows, the newlyweds' first kiss was so steamy, said Smith pal jewelry designer Cynthia Wolff, "it had people giggling."

The $1 million reception had them oohing. Bagpipers played the 120 friends and family into Ashford Castle, a vast, 13th-century estate done up by London planners Fait Accompli as "*A Midsummer Night's Dream* meets *The Secret Garden*," said the bride, now an environmental activist. (The event at which the pair met, and the cause that helped draw them together, was Ted Danson's American Oceans Campaign in Mexico in 1994.) Over 14,000 delphiniums and roses flown in from Holland scented the air as diners enjoyed Beluga caviar, Cleggan lobster and a six-tier carrot cake. The bride surprised the groom with a life-size ice sculpture of Rodin's *The Kiss*, and he reciprocated with a dazzling fireworks display. Before the couple retired in the wee hours, they wowed their guests by dancing an authentic Irish jig. The years of waiting were worth it. "My dad has found it again," said Charlotte. Said the groom: "I still have that feeling that makes your heart sweep up to your throat."

NOVEMBER 22, 2003 Country diva Judd, 39, joined the likes of Roseanne Barr and Patty Hearst when she wed her bodyguard. Her 12-year relationship with Roach, 46, shifted from strictly professional to romantically personal when the two kissed briefly at a '99 birthday party for Judd's manager Kerry Hansen. "It sounds corny," noted pal and Nashville record exec Lisa Ramsey, "but she fell in love with her best friend and he fell in love with his." The bride's mother and former singing partner Naomi Judd sat in the first row with 50 other guests at Garrison United Methodist Church in Leiper's Fork, Tennessee, the site of Roach's proposal in a waiting horse and carriage. Actress

wynonna judd & d.r. roach

sister Ashley acted as matron of honor, and both sisters wore gowns by designer Jane Brooke. The couple's children from previous marriages also got into the act. Judd kids Grace, 7, and Elijah, 8, exchanged sibling vows with Zac Roach, 14. The newlyweds did themselves proud with a reception for 600 at Fontanel, a 27,000-sq.-ft. log cabin near Nashville built by country's Barbara Mandrell. Among banks of lavender and roses, guests began with a fruits de mer bar by the pool and concluded with a six-tier meringue-frosted cake. During the dancing afterward, reported IN STYLE, the bride asked, "Is it hot in here or is it just my love for Mr. Roach?"

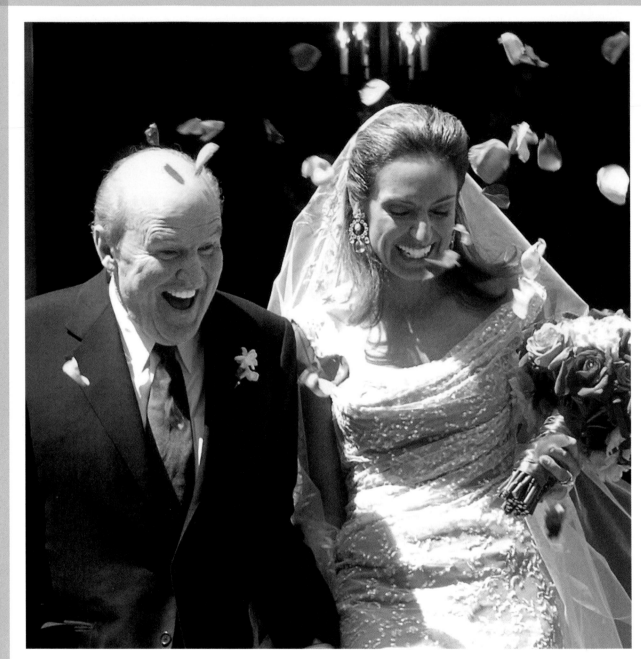

jack welch & suzy wetlaufer

APRIL 24, 2004 Long before they wed, their May-December merger had weathered a lot of business. Soon after Wetlaufer, 45, interviewed the 69-year-old GE boss for the *Harvard Business Review* in '01, she was accused of being the other woman in Welch's acrimonious divorce proceedings with second wife Jane. Wetlaufer lost her job in the scandal, and Welch's reputation took a beating. But their love never wavered. "You can go into the bathroom and [throw up] after talking to us," said Wetlaufer, who wore a café-au-lait Elie Saab gown and 10.8 carats worth of ice on her wedding and engagement bands. "But it's real." The genuineness was apparent when they joined hands in Boston's historic Park Street Church. "It really was like young love," said Wetlaufer's sister Elin Spring. "Except they were older." And richer. The reception for their 90 guests, including *Today*'s Matt Lauer and various titans of business, featured sirloin and salmon in the couple's 26,000-sq.-ft. Beacon Hill townhouse. Wetlaufer's four young children from her first marriage share the home (Welch's four kids with his first wife are grown). After a brief honeymoon, the pair got back to work—cowriting *Winning*, a business primer with a $4 million advance. "Every day is just a blessing," said Wetlaufer.

michelle branch & teddy landau

MAY 23, 2004 She bagged a Grammy dueting with Carlos Santana on 2001's "The Game of Love." Away from the mike, the quirky singer played the timeless sport her own way. Branch, 20, who once said she didn't have time for dating, and longtime beau Teddy Landau, 39, her bass player, were cruising on a friend's charter boat off Mexico's west coast when the pal suggested that the rocky, remote Isla Pardito would be a great place for a wedding. Why not? Returning to the isle, with four other companions looking on, the musicians said their "I dos" before the captain on a white-sand beach. Branch told Landau that the affair would be informal and hid her Morgane Le Fay gown in a bag before the ceremony. Actually, she managed to dress up and down. She set off her dress and 1930s diamond-and-platinum engagement ring with flip-flops and necklaces she made from seashells and fishing line. The surprised groom mixed metaphors in swim trunks and a dress shirt. "The day was romantic," Branch later told a reporter. "Wacky and very true to who we are as a couple."

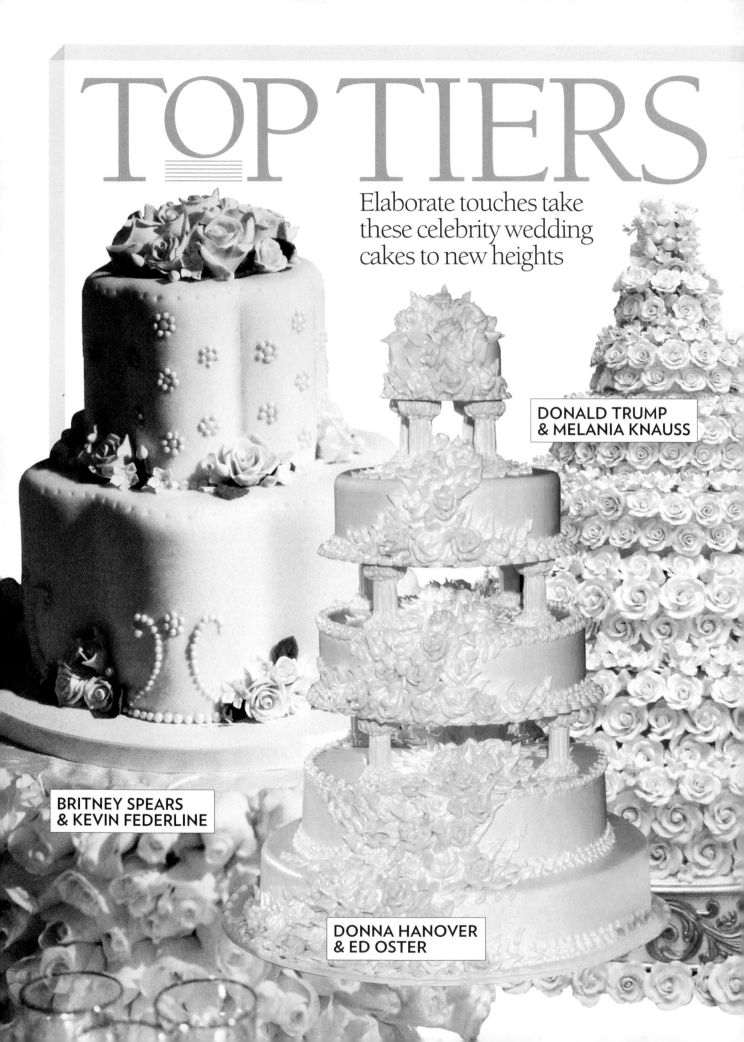

TOP TIERS

Elaborate touches take these celebrity wedding cakes to new heights

DONALD TRUMP & MELANIA KNAUSS

BRITNEY SPEARS & KEVIN FEDERLINE

DONNA HANOVER & ED OSTER

BIGGER AND MORE ORNATE details are coming back," says Sam Godfrey, cake master at Napa Valley's Perfect Endings and creator of sweet sensations for a bevy of A-listers. These celebrity confections show how opulence and personality come into play. For Donald Trump & Melania Knauss, Mar-a-Lago pastry chef Cedric Barbaret spent two months creating nearly 3,000 roses from icing for the 5-foot orange Grand Marnier chiffon cake, which weighed 200 pounds and took five men to carry. Donna Hanover & Ed Oster went traditional with their five-deck delight. White-chocolate pearls divided the tiers of Rob Mariano & Amber Brkich's tiramisu treat. Roses take the cake for Carmen Electra & Dave Navarro, while icing fashioned as a buttoned-up wedding dress was top choice for J.Lo. Godfrey created the white-chocolate butter cake, topped with edible pearls and mounted on a pedestal of roses, for Mr. and Mrs. Federline. "Cakes are an integral part of the wedding," he says. "It's the introduction of the couple's taste and style to their family and friends."

ROB MARIANO
& AMBER BRKICH

JENNIFER LOPEZ
& MARC ANTHONY

CARMEN ELECTRA
& DAVE NAVARRO

MAY DECEMBER ROMANCE

Beauty is in the eye of the older: senior statesmen of business and the arts embrace junior partners in a new lease on life

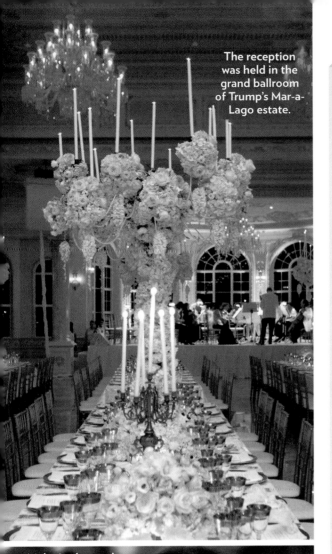

The reception was held in the grand ballroom of Trump's Mar-a-Lago estate.

donald trump
& melania knauss

JANUARY 22, 2005 "It was quick, but beautiful and perfect," said *American Idol* judge Simon Cowell. "I give it a nine." At least. The 58-year-old Trump's third trip down the aisle was the year's super-do, and without a doubt the most expensive extravaganza of the decade. Hillary and Bill Clinton, Katie Couric, Shaquille O'Neal, Kelly Ripa, Star Jones and Barbara Walters were among the 450 guests in Palm Beach, Florida's Episcopal Church of Bethesda-by-the-Sea to see Slovenian model Knauss, 34, wobble down the aisle in her 60-pound handmade Dior with 13 feet of train and a 16-foot veil. On hand were The Donald's four children: Tiffany, 11, his daughter with wife No. 2 Marla Maples, and his kids with No. 1 Ivana, Eric, 21, Ivanka, 23, and Donald Jr., 27. In keeping with the over-the-top event, the newlyweds, who met six years before at a modeling agent's party, kissed three times after saying their traditional vows. "We completely forgot everything around us," Melania said. "It was just us two." At the reception in the Versailles-size Louis XIV-style ballroom at nearby Mar-a-Lago, Trump's private Palm Beach resort, however, they concentrated on their guests. "We did not eat or sit," said the bride. Among all the luxe, the newlyweds' love ruled. As daughter Ivanka told *Vogue,* "I think they're going to be together forever."

Melania changed into a Vera Wang tulle dress. The *Apprentice* boss stuck with his Brioni tux.

ATTENTIVE BRIDE The future Mrs. helps dress ring bearer Cameron Burnett, son of *Apprentice* producer Mark.

billy joel &
katie lee

OCTOBER 2, 2004 "I knew this event was going to be all about food and music," planner Marcy Blum told IN STYLE. After all, Lee, 23, is a chef, and Joel, 55, is, well, the Piano Man. Over 200 guests, including Howard Stern, Don Henley, Paul Reiser and Joel's second wife, Christie Brinkley, witnessed the nondenominational waterside ceremony at the singer's Long Island estate, then got down to the eating and entertaining. A Tuscan-themed dinner was served in a tent decorated like a rustic Italian farmhouse and featured recipes devised in part by the bride. Joel did his part by serenading his bride with "Try a Little Tenderness." She probably needed it. During their first spin to "Moon River," he admitted, "I was just stepping on her feet."

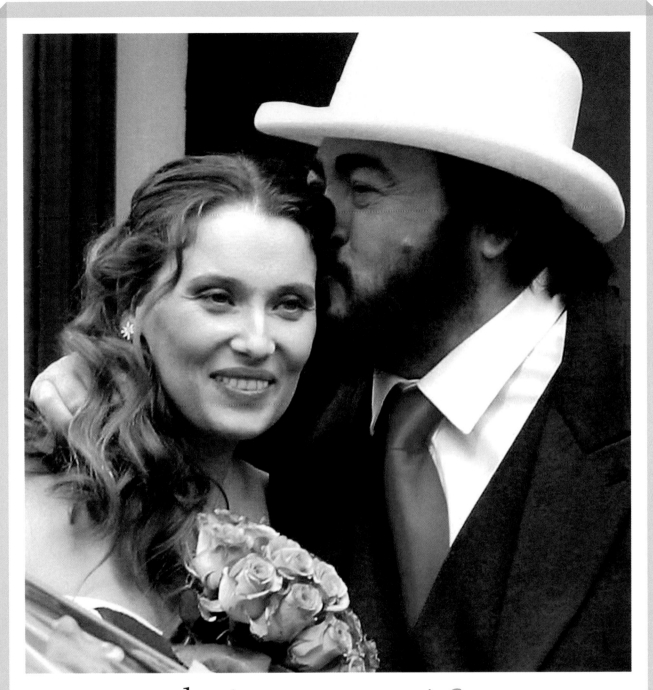

luciano pavarotti & nicoletta mantovani

DECEMBER 13, 2003 When you've hit high notes in opera houses from Barcelona to Chicago and captivated half a million in New York's Central Park, hosting a wedding for 600 or so of your closest friends isn't that big a deal. Just ask 68-year-old Luciano Pavarotti, whose family and friends, including U2's Bono and The Edge, gathered to offer the opera great and his longtime girlfriend, Nicoletta Mantovani, best wishes. The wedding, held in Pavarotti's hometown of Modena, Italy, included a gospel choir that sang "Here Comes the Sun" as the bride arrived half an hour late, and a rendition of "Ave Maria" by another celebrated tenor, Andrea Bocelli. Mantovani, 34, became involved with Pavarotti after she was hired as his secretary in 1993. Ten years later, escorted by her father, Gianni, the bride walked down the aisle in a pale pink Armani gown, while the couple's then 11-month-old daughter, Alice, wore a miniature version of Mama's gown, also by Armani. Pitch perfect.

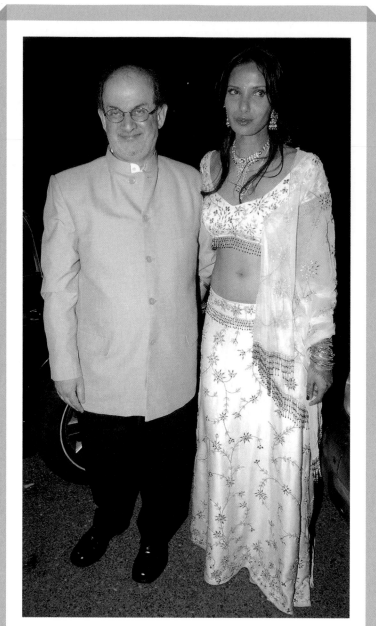

salman rushdie & padma lakshmi

APRIL 17, 2004 "If I ever meet this girl, my goose is cooked," the 56-year-old author thought when he saw pictures of Lakshmi, 33, in a 1999 magazine. Turn on the oven. Later that year, Rushdie, happily freed from an Iranian death edict for his novel *The Satanic Verses,* met the model, Bollywood actress and, appropriately, cookbook author at a party. Despite the age difference and the cultural divide—Lakshmi is Hindu, Rushdie Muslim—"I was taken with him before I could even admit it to myself," Lakshmi told *The New York Times.* Five years later the pair exchanged vows in a large Manhattan photo studio. The 275 guests, Steve Martin and Lou Reed among them, witnessed the nonreligious ceremony, which included Indian customs like the exchange of toe rings as well as a reading from Shakespeare.

paul mccartney & heather mills

JUNE 11, 2002 Could a bride ask for a more perfect wedding day than one that involves marrying the "Cute Beatle"? The model-activist's nuptials to Sir Paul, 59, included a bridal-march version of the song "Heather," written especially by her beloved, as well as a bouquet of 11 red-pink McCartney roses, named in his honor in 1993. The event, at an estimated $3.2 million for 300 guests (including former Beatle Ringo, ex-model Twiggy and guitarist Eric Clapton), took place at Castle Leslie in Glaslough, Ireland. Though it was intended to be private, Sir John Leslie, the 89-year-old owner of the 1,000-acre estate, let the Beatle out of the bag. While speaking with reporters, Sir Jack announced, "[The wedding is] next Tuesday, but it's top secret." McCartney, whose first wife, Linda, died of breast cancer in 1998, told Britain's *Sunday Telegraph,* "More than anything, [my children] want me to be happy." As he and his 34-year-old bride, in a lace gown of her own design, exited the church, bells rang out, an earlier soft rain subsided, and two rainbows appeared.

With 6-year-old Heather in tow and Mary on the way, McCartney's 1969 wedding to Linda Eastman was a simpler affair.

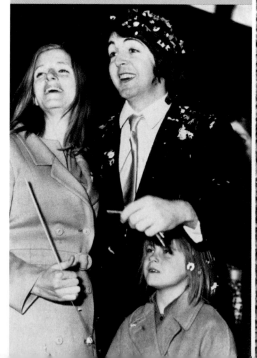

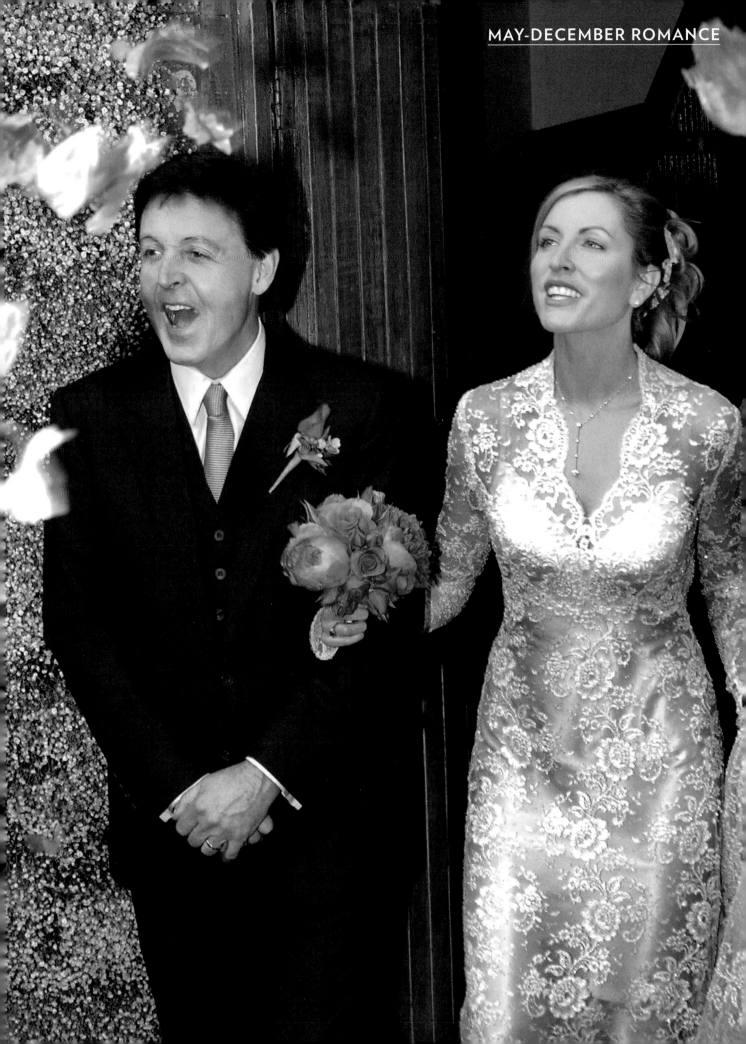

ROMANCE *in* BLOOM

Flowers color and scent the luxe celebrity wedding day

WHETHER WHITE OR RED or wrapped in lace and sentiment, flowers are fragrant shorthand for a bride's wedding wishes. Melania Knauss's "clean" look for her 2005 wedding to Donald Trump shone with thousands of white roses, hydrangeas, gardenias and peonies. For her 2001 fairy-tale wedding to Pierce Brosnan in Ireland, Keely Shaye Smith also went white with a lily-of-the-valley bouquet, the flower of choice for Julianne Moore, Madonna and Tori Spelling. Britney Spears preferred pink and red rose-petal power—4,000 of them—for her 2004 ceremony: Roses starred in bouquets (Britney's was wrapped in a Swarovski crystal-and-lace handle); guests tossed post-ceremony petals and the couple found a heart-shaped heap of rose petals in their bridal suite. Molly Shannon held several hearts in hand when she married Fritz Chesnut in 2004, carrying a simple bouquet encircled with family photos. Her wedding planner, Jo Gartin, suggested this arrangement so that her parents could be with her "in spirit" even though they couldn't physically be there.

BROSNAN & SMITH WEDDING

Smith chose a bouquet of lilies of the valley, as did Julianne Moore.

SHANNON & CHESNUT WEDDING

Peonies with photos so Shannon's parents could walk down the aisle with her. "It was a really nice touch," said Shannon.

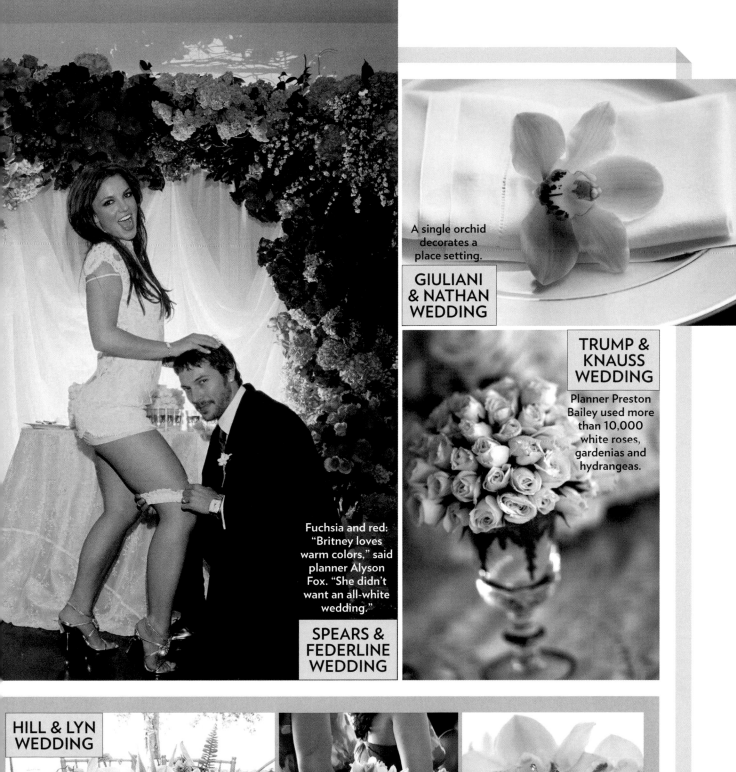

A single orchid decorates a place setting.

GIULIANI & NATHAN WEDDING

TRUMP & KNAUSS WEDDING

Planner Preston Bailey used more than 10,000 white roses, gardenias and hydrangeas.

Fuchsia and red: "Britney loves warm colors," said planner Alyson Fox. "She didn't want an all-white wedding."

SPEARS & FEDERLINE WEDDING

HILL & LYN WEDDING

ISLE STYLE Family-influenced flowers at the wedding of Dulé Hill and Nicole Lyn: Birds-of-paradise graced reception tables in Jamaica, where both families are from; the bridesmaids' dresses reflect the floral landscape; orchids laced with crystals.

ME AND MS. JONES
"I looked at his face and melted," said Star Jones of future husband Al Reynolds. "I literally heard a bell ring." The couple met at a party for Alicia Keys.

IN PRAISE of YOUNGER MEN

Hollywood's leading ladies thank heaven for godsent grooms
who are short on years but promise endless love

star jones & al reynolds

NOVEMBER 13, 2004 "It was unbelievable," said *Today's* Al Roker. "There are awards shows that aren't that good." From her arrival at Manhattan's St. Bartholomew's Church in a Reem Acra taffeta gown and 27-foot crystal-encrusted veil to her huge diamond pendant featuring an *R* with an *A* and *S* on either side, the 42-year-old cohost of *The View* left no detail underplayed (and no product unplugged) when she exchanged vows with investment banker Reynolds, 34. "Every single wedding fantasy I ever had was fulfilled, down to the most handsome groom in the history of the world," Jones said of the lavishly over-the-top white-tie affair. "The best feeling was walking down that aisle and seeing [the groom] smiling from ear to ear." When the pastor asked, "Speak now or forever hold your peace," Chris Rock drew some chuckles—and a stern look from wife Malaak—when he loudly stamped his foot. During the ceremony, which included the 60-member Broadway Inspirational Voices choir and singer Marva Hicks performing the Lord's Prayer, the bride's mind was elsewhere. "The only thing I could think of was 'I love this man. I love this man with every ounce of my being,'" said Jones. "We both got very emotional. The moment was perfection." Pastor A.R. Bernard prompted cheers during the ceremony when he announced, "We have heard what the cynics have said about this marriage . . . now we have heard what you have to say." Afterward, the couple, who hooked up the year before at an Alicia Keys CD release party, rejoined their 450 guests, including the bride's *View* costars and luminaries from Samuel L. Jackson to Donald Trump to Hillary Rodham Clinton, at the Waldorf-Astoria hotel for lobster in an all-white room gleaming with Swarovski crystal. Then it was on to dancing in a red-and-hot-pink ballroom that planner David Tutera pronounced "a sexy lounge." Said Jones pal Kim Cattrall: "If I ever get married again, I want to marry Star, because she knows how to do this right!" Now, with the big day behind them (as well as the 10-day honeymoon in Dubai), Jones says she and her husband "plan to take back a bit of our privacy." The wedding, she added, "was for the 8-year-old in me, but the marriage is for the woman I have become."

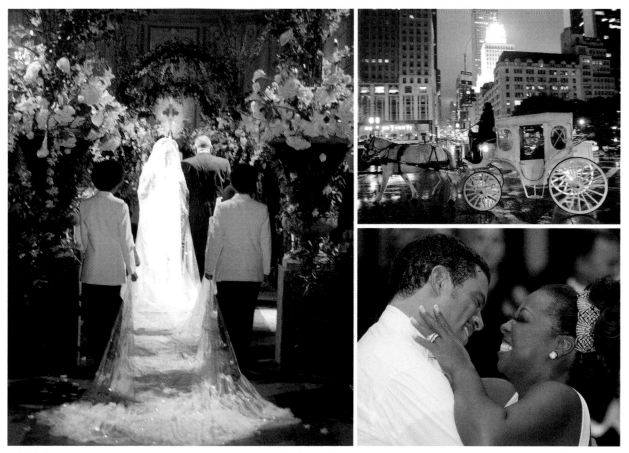

LADY'S NIGHT Jones wed Reynolds at St. Bartholomew's Church in New York City. She said she fulfilled her "ace fantasy" on the eve of her wedding by riding to her suite at the Waldorf-Astoria in a white horse-drawn carriage as her bridesmaids sang the '60s hit "Chapel of Love." They took their first spin on the dance floor to "Fly Me to the Moon."

mira sorvino & christopher backus

JULY 2, 2004 She's won an Oscar; he's appeared on *The O.C.* She's worked with Woody Allen; he with *Will and Grace*. Sorvino, 36, and Backus, 22, fell quick and hard, Hollywood style. So much so that one ceremony to celebrate just ▮▮uldn't do. Though the couple ▮hose daughter Mattea Angel was born November 3) held a private civil ceremony at the Santa Barbara, California, courthouse on June 11, Mighty Mira and her legendary father, actor Paul Sorvino, organized a grandiose affair to kick off the now-and-forevermore stage of the couple's lives. While the younger Sorvino was in Italy to receive an acting award on June 29, she and Sorvino senior put a call in to Ranieri Colonnese, the manager of Capri's exclusive La Residenza hotel, to help organize big day No. 2. Three days later, with cases of Fiano Feudi di San Gregorio white wine chilled and 11 tables set with l▮▮ tablecloths and antique silver ▮▮▮▮▮ the bride, dressed in an ▮rmani gown, and her groom exchanged I dos in a small neoclassical temple with 100 of their closest family and friends. "Mira looked like a young girl in seventh heaven," said one guest. Backus, added another, "looked like his heart was singing." The scene-stealer for the evening? Papa Sorvino, respected as much for his pipes as his onscreen presence, sang a Neapolitan ballad, while guests feasted on pasta in lobster sauce and a three-tier chocolate sponge cake.

molly shannon & fritz chesnut

MAY 29, 2004 Molly Shannon kept *Saturday Night Live* audiences in stitches for six years, but when a mutual friend introduced the comedian to painter Fritz Chesnut, 31, in 2000, it was Shannon, 39, who was tickled pink. "I was so proud of him and thought, I hope people think he's my boyfriend," she told a reporter. The magic moments took place in a rose-petal-strewn courtyard at the Four Seasons Resort in Santa Barbara, California, in front of 170 guests, including actor John C. Reilly, *Will & Grace*'s Megan Mullally and former *SNL* costars Will Ferrell and Jimmy Fallon. The blushing, bubbly bride was costumed in an off-white "garden dress" designed by *SNL* wardrobe department head Dale Richards. At the reception, guests enjoyed Alaskan halibut, beef tenderloin and carrot cake. Said Shannon, now the mother of the couple's two children: "We could tell that our friends were having fun. The day was a happy dream."

katey sagal & kurt sutter

OCTOBER 2, 2004 Much like love and marriage, Katey Sagal and disco go together like a horse and carriage. When the former *8 Simple Rules* and *Married with Children* star, 49, wed her boyfriend, Kurt Sutter, 42, a writer and producer for *The Shield*, she was determined to get down and boogie-oogie-oogie. An hour after the close-knit nondenominational service—attended by 32 friends and Sagal's children Sarah, 10, her maid of honor, and Jackson, 8 (anticipating a few tears, tissues with the couple's image were on hand)—176 more guests arrived at their Los Feliz, California, Spanish colonial for the Moroccan-inspired celebration. The party invitations humorously read, "On the afternoon of October 2nd, Katey Sagal and Kurt Sutter will become husband and wife . . . if that works out, that same evening they will celebrate their new union with a wedding day gala." Work out it did, and after blood-orange martinis and a buffet, revelers headed to the dance tent, which was glowing with rose-covered chandeliers, to watch Mrs. Sutter groove in a Jean Harlow-esque Reem Acra silk charmeuse gown to "Stayin' Alive" and "Get Down Tonight." Said Sagal to IN STYLE: "It was everything I wanted it to be. I'm just a little ol' disco queen."

julianne moore *&* bart freundlich

AUGUST 23, 2003 When the four-time Academy Award nominee wed her director boyfriend, Bart Freundlich, 33, she decided to keep it small with a little help from her friends. The couple tied the knot in a cozy ceremony in New York City performed by actor James LeGros in the garden of their Greenwich Village home, with son Caleb, 5, and daughter Liv, 1, in attendance. Actress Ellen Barkin provided a pair of earrings, and Freundlich's friends, chefs Josh Eden and Wylie Dufresne, the feast. Moore, 42, and Freundlich started dating after they met during filming of his 1997 movie *The Myth of Fingerprints*. The North Carolina native once admitted she used to shy away from on-set romances. "That was a line you couldn't cross, like getting involved with your teacher," she said. So why break the rules and marry him? "He asked me," she said.

PARTING WAYS

Though Hollywood prefers a happy ending, these celebrity couples who have loved and lost have a different story to tell

charlie sheen & denise richards

JUNE 2002 – MARCH 2005 Rumors that Sheen, 39, was slipping back to the wild ways that landed him in Heidi Fleiss's appointment book may have prompted Richards, 34, to file for divorce, citing "irreconcilable differences." The *Two and a Half Men* star called the allegations "unconscionable." But insiders contend that Richards (*Wild Things, Drop Dead Gorgeous*), mother of the couple's 1-year-old daughter Sam and pregnant with their second child, was concerned about the kids' upbringing. Said a pal: "She just wants to move on." Daughter Lola Rose Sheen was born June 1 with her father at the bedside, and the family was together again on Father's Day. But her parents were not getting back together. "He wanted to be there, and she agreed to it," said a Richards friend.

brad pitt
& jennifer
aniston

JULY 2000 - JANUARY 2005 Married on a cliff surrounded by Friends, a full gospel choir and 50,000 flowers, they were, said pal Matt Damon, "the couple you want to be." But the 41-year-old Pitt knew the reality. He once admitted, "It's part of the illusion that this life is so fabulous." Their breakup, though punctuated with rumors of an affair between Pitt and Angelina Jolie, was handled with A-list smoothness. Said Jen friend actress Kathy Najimy: "They are leaving their relationship with the same grace and respect that they went into it with." In her divorce filing, Aniston cited "irreconcilable differences" and asked that her maiden name be restored: Jennifer Joanna Aniston. He said, "I'm not sure it really is in our nature to be with someone for the rest of our lives." She said, "Is he the love of my life? . . . I don't know. I think you're always sort of wondering."

nicolas cage &
lisa marie presley

AUGUST 2002 – NOVEMBER 2002 Onscreen, he starred in *Gone in 60 Seconds*, but at home his second marriage crashed on the first turn. Cage, 38, and Elvis's only child parted company after a mere 108 days. "It was a big mistake," said the thrice-wed Presley, 34. "We shouldn't have been married in the first place." The predicament: She was focused on Scientology and her two children from her first union; he was working almost constantly. "I'm not going to talk about the divorce," Cage said. "But I loved her."

liza minnelli & david gest

MARCH 2002 – JULY 2003 With Michael Jackson, Elizabeth Taylor, David Hasselhoff and Diana Ross among the 1,000 celebrants at the couple's wedding, it was, said Carol Channing, "like when they opened the World's Fair." Sixteen months later it was a three-ring circus. Event promoter Gest, 50, kicked off the festivities by suing the 57-year-old entertainer for $10 million. He colorfully claimed that the 5'4" diva, whom he said was "unable to be effectively merchandised," beat him severely in vodka-fueled rages. Minnelli countersued for $2 million, saying her fourth husband defrauded her of concert receipts while acting as her agent. They both also sued each other for divorce. "I hoped that the end of my marriage," she said, "would be handled with mutual respect and dignity." Nope. In 2004, Minnelli's former bodyguard M'Hammed Soumayah sued her for assault and breach of contract, claiming that she forced him to have sex with her. The *Cabaret* star countered, alleging that Soumayah was conspiring with her ex to destroy her. And as the unseemly divorce ground on through March 2005, New York Justice Jane Solomon had enough. "There is all this garbage," she said of the proceedings. "It's undignified, it's unprofessional, and it will stop."

christian slater & ryan haddon

FEBRUARY 2000 – FEBRUARY 2005 The quarrelsome union ended in a split decision. The contentious couple squared off against each other in 2003, when TV producer Haddon, 32, cut the 34-year-old actor with a wineglass during an argument at a Las Vegas casino. Stitches were required to close the head wound. They also had a devilish influence on their pals. The couple led a lone Ben Affleck, then famously affianced to Jennifer Lopez, on a party-hearty foray to a Vancouver strip club, also in 2003, a widely publicized event that spelled the end of Bennifer. Slater and Haddon's decision to dissolve the battle-scarred bond was mutual, as was their agreement to share custody of their kids, Eliana, 3, and son Jaden, 5. Said Slater's publicist Evelyn Karamanos: "They remain committed to raising their two young children together."

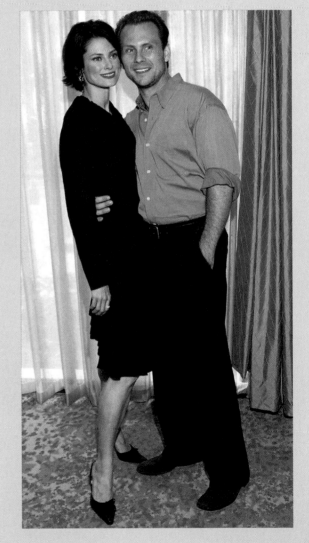

mena suvari & robert brinkmann

MARCH 2000 – MAY 2005 When they eloped, it seemed in a way that life was imitating art. In *American Beauty*, Suvari's cheerleader is the fantasy of a much older man. Offscreen, the actress was merely 21 when she wed the 38-year-old cinematographer. "He's made me the happiest I could ever be," she said. She was also carrying on a kind of family tradition: Her parents are 24 years apart in age. "What's age?" she asked. When a fan at the 2000 Independent Spirit Awards asked Brinkmann if he was her boyfriend, he replied, "No, I'm her husband," letting the cat out of the bag. The pair had met on the set of *Sugar & Spice,* a 2001 teen comedy. "I love coming home to my husband and my house," she told *Cosmopolitan* in June 2000. No longer. Suvari, who costarred in two *American Pie* comedies, filed for divorce in Los Angeles.

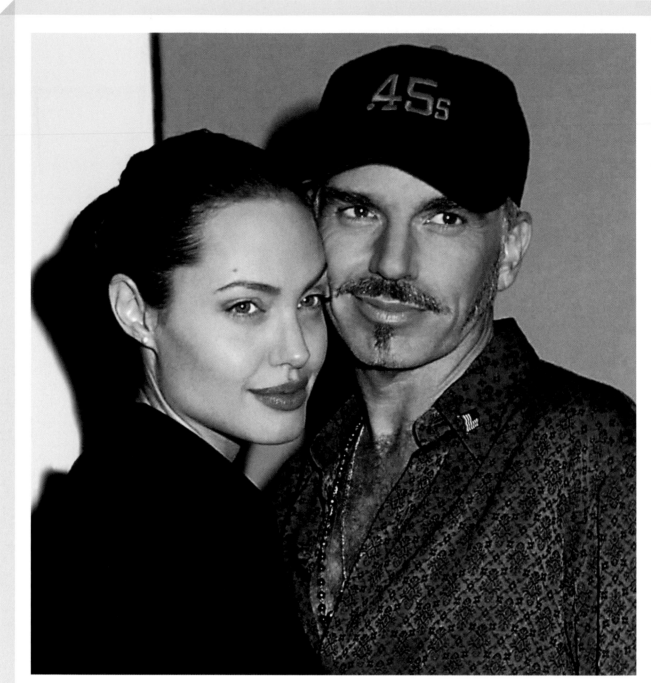

angelina jolie *&* billy bob thornton

MAY 2000 – JULY 2002 As proof of their passion, the Oscar winners got tattoos of each other's names, carried vials of each other's blood, spoke publicly about their sexual habits and exchanged deep kisses on the red carpet. In the end, they exchanged court papers. Jolie, 27, filed for divorce from Thornton, 47, after 25 months of marriage—and four months after they adopted a Cambodian baby boy, Maddox. It was her second split, his fifth, and his third to end after just two years. Thornton left his then fiancée, actress Laura Dern, for Jolie, whom he met on the set of the 1999 drama *Pushing Tin*. Jolie sought sole custody of Maddox, whom she first met in a Cambodian orphanage in 2001 during one of her trips as a goodwill ambassador for the United Nations. Though the couple had made a joint announcement about their son's adoption in March 2002, a spokesman for the Immigration and Naturalization Service in Washington, D.C., said, "Only her name is on the [adoption] papers." Said Jolie's mother, former actress Mercheline Bertrand: "I thank God she has her beautiful baby to love and protect." Jolie's attorney Laura Wasser said the split "was amicable, and they're glad it was completed expeditiously."

THE ALMOST WEDDING

A ONCE FLASHY ROMANCE FIZZLED OUT WHEN BENNIFER FINALLY CALLED IT QUITS

Fans everywhere were fooled by the rock that she got, thinking that surely a $1.2-million, 6.1-carat pink diamond ring would seal the deal for Jen & Ben. Yet on September 10, 2003, Lopez and Affleck, the most buzzed about couple of that year, postponed their planned Santa Barbara wedding just days before they were to exchange vows in front of 200 guests, including Bruce Willis and Colin Farrell, topping off the media frenzy their relationship had become. While the couple were dining post-breakup at L.A.'s Ivy restaurant, a photographer asked Lopez why she and Affleck split. "Because of you," she snapped. Whether the blame lies with aggressive paparazzi or public pressure, instead of witnessing the couple's "very traditional" ceremony, we endured the tragic circumstances—not only their loss of much of the nonrefundable $2 million tab for the big day, but the loss of our beloved Bennifer. That is, until Jenny from a different block (Garner, that is) came along. As for Lopez, she decided that this time around, she'd keep her relationship (and eventually her wedding with singer Marc Anthony) on the low.

THE ROCK
that launched more celebrity rocks. Lopez's now infamous pink diamond engagement bling.

WEDDING PLANNER
The wedding was to have been "incredibly romantic and very Art Deco," said a friend. Lopez enlisted A-list party guru Sharon Sacks.

COULDA WOULDA SHOULDA
Guests were to be shuttled to Santa Barbara's Our Lady of Mount Carmel church for a "very traditional" ceremony, officiated by the resident priest. Then it would have been on to the Montecito estate of businessman Frank Caufield, where the pool had been covered with a transparent dance floor. The newlyweds were to spend the night at the $1,875-a-night Kennedy Suite at the San Ysidro Ranch hotel, where John F. Kennedy honeymooned.

john stamos & rebecca romijn

SEPTEMBER 1998 – APRIL 2004 Beauty fades, of course, so it should have been no surprise that the union of the dazzling duo lost its bloom. There was no third party, say friends. Bicoastal careers simply ground away at togetherness. In the last years of their marriage, *Full House* alum Stamos, 40, lived in New York City while starring on Broadway and shooting a new sitcom for ABC, *Jake in Progress* (about the single life). Former model Romijn-Stamos, 31, spent most of the year in L.A. and away on locations for *X-Men* and *The Punisher*. Pals were saddened by the split. "I know they were very much in love when they got married," said John Travolta, Romijn-Stamos's *Punisher* costar. For his part, Stamos, who enjoyed the bachelor life after the separation, said, "We both weren't getting everything we needed out of our marriage. It was time to move on for both of us." His ex-wife was less stoic. She told Jay Leno, "It's sad and painful. I'm still trying to get my head around it."

ted turner & jane fonda

DECEMBER 21, 1991 – MAY 2001 TedandJane. Their names were one around Atlanta, and when they began their courtship in 1989, they were deemed an odd couple. She was a glamorous two-time Oscar winner; he was the brash-yet-brilliant billionaire who founded CNN. But on her 54th birthday, the two wed (the third time for each) at Turner's 8,100-acre plantation near Tallahassee, Florida. For the next eight years, they publicly vowed unwavering mutual support. Turner, 53, began to passionately back liberal causes. "I'm sure my father—God rest his chauvinistic soul—was rolling around in his grave," he said. Fonda sold her L.A. home and left her 31-year film career. "Wherever Ted goes, I go," she told an interviewer. But by January 2000 Turner's go-go-go seemed too much for the former fitness guru, and the pair announced that they had "mutually decided to spend some time apart." In 2001 TedandJane became the talk of Atlanta again, when the city's "royal couple" called it quits for good.

sharon stone & phil bronstein

FEBRUARY 1998 – JULY 2003 The couple that survives together stays together? Not so for Stone, 45, and San Francisco newspaper editor Bronstein, 52. During five years of marriage, they lived through the newsman's 1999 heart angioplasty and his being savagely bitten in the foot by a Komodo dragon during a private tour of the Los Angeles Zoo in '01. (She used a sock as a tourniquet.) That same year, the actress nearly died of a brain hemorrhage. But shared affliction didn't cement the relationship. "They just drifted apart," said a friend, noting that both were focused on their work. The pair announced an "amicable" separation and intended to share custody of Roan, their 3-year-old son.

Their Royal Highnesses the Prince of Wales and the Duchess of Cornwall wed in a small civil service at Windsor's town hall. The televised blessing followed at St. George's Chapel.

CHAPTER 8

LOVE
at LAST

They'd been together for years, but
circumstances, obligations or procrastination kept them
from the altar. It all ended with a vow

The royal couple were wed in a private civil ceremony, followed 90 minutes later by this blessing by the Archbishop of Canterbury at St. George's Chapel, Windsor. Princes William and Harry show their approval.

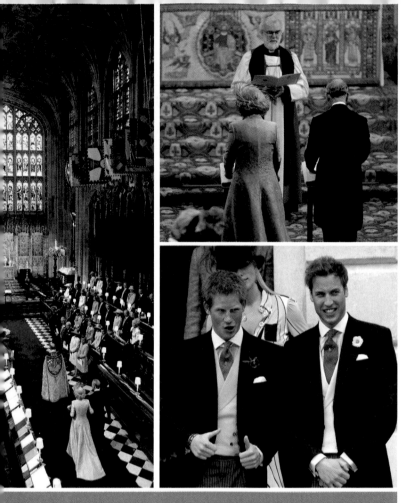

prince charles & camilla parker bowles

APRIL 9, 2005 Far less of a spectacle than Prince Charles's 1981 royal ceremony with then-20-year-old Diana Spencer, the union of Charles, now 56, and Camilla Parker Bowles, 57, will be remembered as the most talked-about civil ceremony in history. The famous couple, who met more than 30 years ago, chose a private civil service because the Church of England frowns upon divorcés remarrying. They officially commenced their union as man and wife in front of 30 or so guests during a 20-minute ceremony at Windsor's Guildhall. Ninety minutes later, at St. George's Chapel, the blessing of their union—the guest list for which grew to approximately 750, including Prime Minister Tony Blair, musician Phil Collins and comedian Joan Rivers—included a confession read by Charles and Camilla that reportedly stated, "We acknowledge and bewail our manifold sins and wickedness." At a tea-and-finger-food reception thrown by Charles's parents, Prince Philip and the Queen, at Windsor Castle's State Apartments, Charles thanked his "darling Camilla," now going by the title Duchess of Cornwall, for "taking on the task of being married to me." After slicing the organic fruitcake with a sword that belonged to Charles's great-grandfather King George V, the jubilant couple left for their honeymoon in a Bentley decorated with red and blue balloons and signs—placed there by their children—that read "Just Married," "Prince + Duchess" and "C+C" on the windows.

I MARRIED A COMMONER
IN A MODERN REVOLUTION, TWO REGULAR GIRLS SNAG PRINCES

Just one week apart from each other, two of Europe's most eligible bachelors were taken off the market when they each wed—gasp!—commoners. Denmark's **Crown Prince Frederik**, 35, married **Mary Donaldson**, 32, a law-school graduate from Hobart, Tasmania, in Copenhagen on May 14, 2004, in front of royals, nobles, prime ministers and diplomats. The prince met his princess-to-be at the Slip Inn, a Sydney pub, during the 2000 Olympics. (According to the Australian Associated Press, a banner strung from the hotel read "Meet Your Prince at the Slip," and the bar served a "Something About Mary" drink to mark the wedding day.) During the televised ceremony, the prince told a teary-eyed Donaldson, "I love you, Mary. Come, let's go, come let us see. Throughout a thousand worlds, weightless love awaits."

On May 22 **Crown Prince Felipe**, 36, followed Frederik's lead, marrying **Letizia Ortiz**, 31, a former TV anchorwoman, at Madrid's Almudena Cathedral. In front of 1,400 guests, including such well-wishers as former South African president Nelson Mandela and Jordan's Queen Rania, Ortiz, a divorcée, walked up the aisle in a televised ceremony toned down in remembrance of the March 11 terrorist attacks in Madrid. It marked the first royal wedding in the Spanish capital in 98 years, and the first time the future queen did not come from aristocracy.

rudy giuliani & judi nathan

MAY 24, 2003 As former mayor of New York City, Rudolph Giuliani has cut his share of ribbons at ceremonies. But the 58-year-old's own special ceremony found him tying the knot with girlfriend Judith Nathan. After a few years of dating and generating a few unfavorable headlines, the stoic politician, who became known as "America's mayor" in the aftermath of 9/11, married Nathan, 48, at Gracie Mansion, the city's mayoral residence, in front of 400 or so guests. For their very private nuptials, N.Y.C. mayor Michael Bloomberg officiated and the bride wore a Vera Wang oyster-colored silk gown. Her husband, not noted much for his softer side, surprised Nathan with a Piaget pearl-and-diamond necklace that matched her tiara. "They're mad for each other," said Wang. Columnist Cindy Adams concluded, "For all of New York's cynicism, nobody could take away from the beauty of the moment."

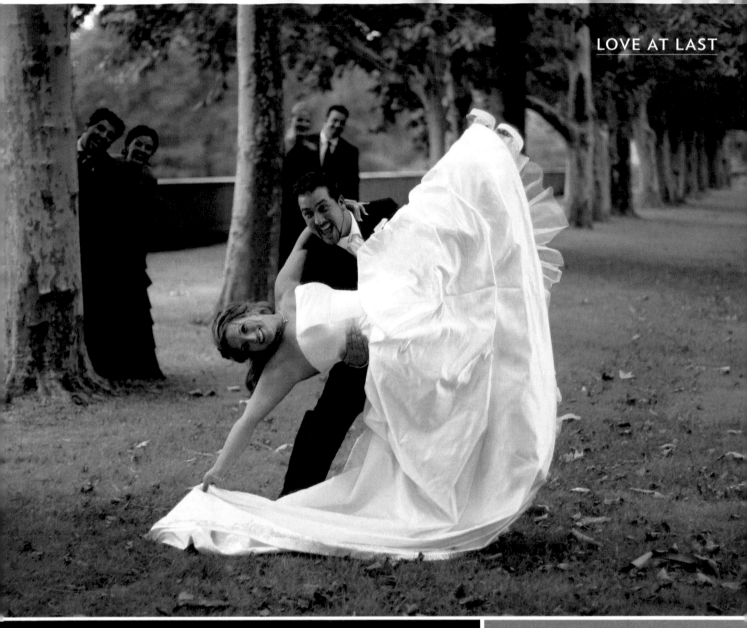

Said Baldwin of her 11-year romance with Fatone: "We've been through good, bad and ugly. It can only get better."

joey fatone & kelly baldwin

SEPTEMBER 9, 2004 When 'N Syncer Joey Fatone, 27, married his high school sweetheart, Kelly Baldwin, also 27, the day was filled with laughs. At the ceremony at Long Island's Oheka Castle, Fatone got so choked up on his vows, he blurted out an expletive that sent giggles through the crowd of 255, including bandmates Lance Bass, JC Chasez, Justin Timberlake and Chris Kirkpatrick. After dinner, pop band Smash Mouth played and guests amused themselves with a Ferris wheel, bumper cars and giant slide, which Fatone's mom went up and down on in her ballgown.

AGAINST THE ODDS

EVERYONE IS SEEING DOUBLE AT THE ALTAR AS GAY MARRIAGE BECOMES LEGAL IN OTHER COUNTRIES, AND AT HOME

MELISSA ETHERIDGE & TAMMY LYNN MICHAELS

On September 20, 2004, a high-powered lineup of guests including Steven Spielberg, Sheryl Crow, Tom Hanks, Ellen DeGeneres, Jennifer Aniston and Al and Tipper Gore gathered at Dick Clark's oceanside Malibu estate to watch two brides, Melissa Etheridge, 42, and Tammy Lynn Michaels, 28, of The WB's series *Popular*, promise everlasting love—and post-concert foot rubs. Etheridge, who has two children with former partner Julie Cypher, popped the question at Spielberg's Hamptons home. At sunset, the brides, both wearing

Badgley Mischka—Etheridge in a pantsuit and Michaels in a gown and jacket—proceeded barefoot down separate aisles to an arch of blue and pink hydrangeas. On their way in, the 150 friends and family who witnessed the commitment ceremony were each given rocks to bless, which the brides later collected after being declared "beloved wives" by the transdenominational reverend. The ceremony was the talk of the event. "That was the most beautiful exchange of vows I've ever heard," said Spielberg. The celebration kicked off with a Mexican buffet and ended on the dance floor. "Sally Field

LOVE AND—FOR SOME—MARRIAGE Tammy Lynn Michaels with Melissa Etheridge in Malibu. *Amazing Race 7*'s Alex Ali and

was still dancing when a lot of us left at midnight," one guest reported. Though the marriage is not legally recognized, that did not faze either brides or guests. As Hanks told a reporter, "Whenever two people stand up and say, 'I will love you forever,' that is a beautiful way to spend an evening." Michaels took her partner's name. "Getting married is about having your feet on the ground," she said.

LYNN WARREN & ALEX ALI The pair of executive assistants from *The Amazing Race 7* traveled to Ottawa in Ontario, one of several provinces in Canada where same-sex marriage was expected to become law. The June 1, 2005, nuptials were broadcast live on a local radio station. Said Ali: "We didn't win the $1 million, but Lynn and I have won so much." Later in July, Canada joined the Netherlands, Belgium and Spain in passing a law making same-sex marriage legit across the country.

ROSIE O'DONNELL & KELLI CARPENTER On February 26, 2004, Rosie O'Donnell and her partner of six years, Kelli Carpenter, said "I do" in a civil ceremony in San Francisco, where mayor Gavin Newsom had recognized 3,300 same-sex marriages. Several other mayors followed

suit. O'Donnell told *Good Morning America* that her wedding was in protest of President Bush's "hateful" proposal to seek a constitutional amendment banning gay marriage. Though O'Donnell was on a mission, it was not devoid of sentiment. "I had tears when I saw tears well up in their eyes," recalled city treasurer Susan Leal, who pronounced them "spouse and spouse," designations the couple chose. Bush's proposal was shot down by the Senate in July, which left the decision to state governments. Massachusetts opted to legalize, while California issued a void of all licenses.

ELTON JOHN & DAVID FURNISH Randy Jones, 51, the original cowboy of the Village People, and Will Grega, an acid lounge artist and his boyfriend of 20 years, were married May 7, 2004, by a reverend at club Rumor in New York. Though New York doesn't recognize gay unions, Jones said, "It's only a matter of time before courts rule in favor of what's morally right and humanly decent." In the same spirit, Elton John, 58, announced plans in April to marry his longtime partner, Canadian film producer David Furnish, 42, after gay partnerships become legal in Britain, after December 5, 2005.

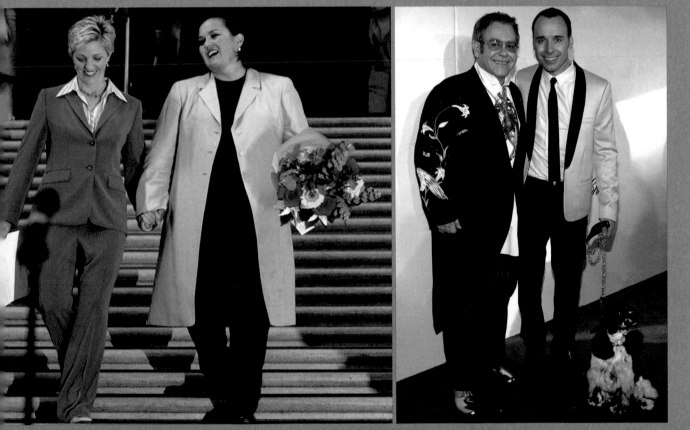

Lynn Warren in Ottawa, Canada. Kelli Carpenter and Rosie O'Donnell, so happy together. Elton John plans to wed David Furnish.

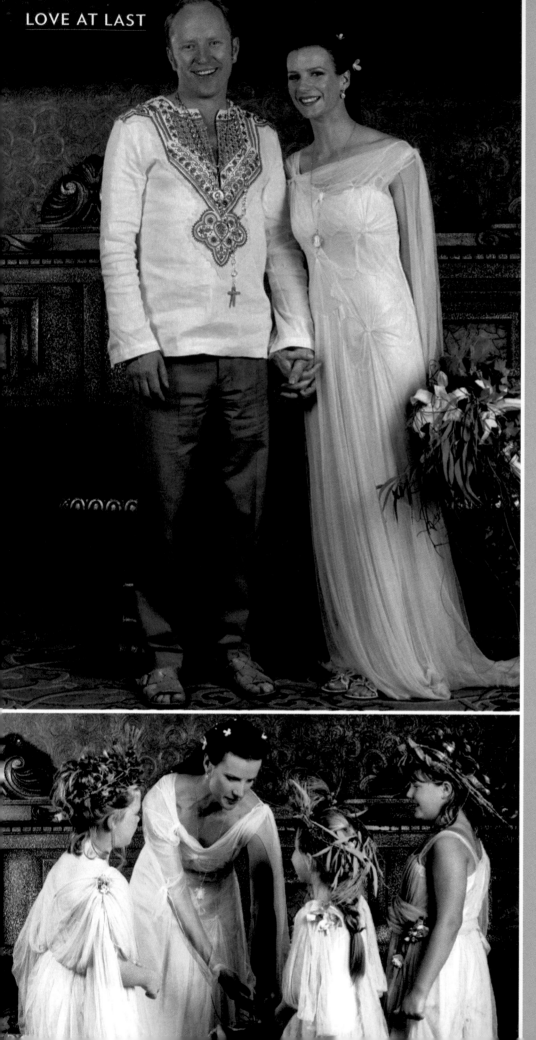

rachel griffiths & andrew taylor

DECEMBER 31, 2002 Up until 2002, Aussie actress Rachel Griffiths had experienced a couple of "I do" moments, but never her own. The Golden Globe winner, who stars as Brenda on HBO's *Six Feet Under,* had appeared in 1994's *Muriel's Wedding* and 1997's *My Best Friend's Wedding,* but on New Year's Eve, Griffiths had her true moment in the spotlight. At sunset, she married fellow Aussie Andrew Taylor, whom she smooched when the two were 17-year-old students at neighboring Catholic schools in Melbourne. Though they never dated then, the pair did meet back in the chapel of Griffiths's old Star of the Sea school to walk the aisle before 140 guests, including *Muriel's Wedding* star Toni Collette. (Griffiths watched Collette spin her new husband, David Galafassi, around to ABBA's "Dancing Queen" 11 days later.) The candlelit nuptials were officiated by her uncle, a Jesuit priest. "The ceremony was delightful," said Kate Kennedy, the bride's best friend. "There was a lot of spirituality, a lot of heart and a lot of family." For the big day, Griffiths, 34, wore a silk gauze gown by Alberta Ferretti, while Taylor, whose 35th birthday was celebrated at midnight, wore a vintage Roberto Cavalli shirt and Helmut Lang silk-wool suit. Her bridesmaids? There weren't any. In a statement, the couple explained, "The bride believes women in their 30s should never appear in matching dresses."

FAIRY TALE ENDING
Six Feet Under's Rachel Griffiths wed artist Andrew Taylor in their native Melbourne.

ed burns
& christy
turlington

JUNE 7, 2003 When the fast-paced life of celebrity becomes so filled with the flash of photographers' bulbs, whether on the runway or on the red carpet, you sometimes need to slow things down and keep it simple. Such was the case for writer-director-actor Ed Burns, 35, and his wife, supermodel-entrepreneur Christy Turlington, 34. The couple, who met at a party in the Hamptons in 2000, were set to wed in October 2001 but decided to postpone in the wake of 9/11. Then, in March 2002, they broke up. Their split lasted several months; in the autumn they reconciled. A year and a half later, they tied the knot in a traditional Catholic ceremony with a seven-person choir at San Francisco's Saints Peter and Paul Church. The bilingual bride, who speaks Spanish and English, wore a silk-and-lace cap-sleeved Galliano gown and walked down the aisle on the arm of her longtime friend, U2's Bono (Turlington's father, Dwain, died of lung cancer in 1997). The only thing not understated was Turlington's jewelry, which included a 42-carat diamond necklace and 6-carat diamond drop earrings from New York City's blingmaster Jacob & Co. The reception was held at the Asian Art Museum, where 200 guests, including Vin Diesel and Sting, were on hand to offer their well wishes, and the couple shared a quiet honeymoon at Las Alamandas resort in Mexico. "It was very private, very romantic and very sweet," a rep for the property told a reporter. Of his beloved, Burns has said, "We want the same things out of life," including a family. On the list for certain: love, happiness and Grace, the couple's now 2-year-old daughter.

HELLO, I LOVE YOU

CELEBRITIES RUSH IN FROM "PLEASED TO MEET YOU" TO SAYING "I DO"

BRITNEY SPEARS & KEVIN FEDERLINE Just call her spontaneous. In April 2004, one week after meeting the dancer at an L.A. club, Spears invited him on her European tour. On the flight home, she proposed. Kevin initially said no; but minutes later, *he* proposed. The pair wed that September in secret at their planner's house in Studio City, California.

RENÉE ZELLWEGER & KENNY CHESNEY Theirs is a tale of crushes come true. In 2002 Chesney told a reporter he thought Renée was sexy. "You never see her coming, then wham!—there she is." At a January 15, 2005, tsunami telethon, Zellweger saw Chesney coming, and "she was going to pass him a note," said a friend. Instead, they were formally introduced back-

It was a short one-month trip to "Will you marry me?" for Sorvino and Backus

stage. Four months later, they said I do in the Virgin Islands on May 9.

STAR JONES & AL REYNOLDS From dance floor to altar: Reynolds proposed just three months after grooving with Jones at an Alicia Keys party. The two married on November 13, 2004, one year to the day following that first dance.

MIRA SORVINO & CHRISTOPHER BACKUS The actors met at a party in August 2003. One month later, there was no guessing that it was love when Backus proposed. They celebrated Italian-style July 2004 on the isle of Capri.

SELMA BLAIR & AHMET ZAPPA One blind date and eight days later, actor-rocker Zappa gave the actress a highlighter pen to draw a ring on her finger and they tied the knot in January 2004.

MARRIED AGAIN

THE SECOND TIME'S A CHARM

Robert De Niro, 53, married **Grace Hightower**, 44, in 1997, but they looked to be divorcing in 1999. The divorce was never finalized, however, and the couple renewed their vows at De Niro's home near New York's Catskill Mountains on November 20, 2004, in front of an A-list crowd including Martin Scorsese, Ben Stiller and Tom Brokaw.

◆

In 1995, to mark their 25th anniversary, **Billy Crystal** and his wife, **Janice Goldfinger,** exchanged rings (their originals had been stolen) in front of a rabbi and later celebrated at a black-tie reception in Malibu.

◆

After her husband, **René Angélil,** was diagnosed with cancer and she bade temporary farewell at a concert

in Montreal, **Celine Dion**, 31, and Angélil, 57, had a second ceremony awash in gold in January 2000, five years after their first, for 250 people at Caesar's Palace in Las Vegas.

◆

Marc Anthony and former Miss Universe **Dayanara Torres** renewed their vows at a lavish celebration in Puerto Rico in December 2002. He was divorced just days before marrying Jennifer Lopez in June 2004.

◆

With Justin Timberlake, Chris Rock and Jon Lovitz among the 500 guests looking on, **Ozzy Osbourne,** 54, and wife **Sharon,** 50, renewed their vows in a traditional Jewish ceremony at the Beverly Hills Hotel. The cussing couple first wed on a beach in Maui 20 years before.

shaquille o'neal & shaunie nelson

DECEMBER 26, 2002 Basketball powerhouse Shaquille O'Neal, 30, scored major points when he married former film marketer and longtime girlfriend Shaunie Nelson, 28. The lavish ceremony at the Beverly Hills Hotel was attended by 248 guests, including actress Vivica A. Fox, singer Vanessa Williams and Lakers guard Brian Shaw, who was almost as thrown as the paparazzi by the secrecy of the day's events. "I didn't know it was black tie," he admitted. The affair, dubbed the Royal Wedding by wedding planner Mindy Weiss, included a carriage-shaped cake, a $65,000 Michelle Roth bridal gown with a $5,000 beaded veil, and a rendition of "Here and Now" by R&B crooner Luther Vandross. Said O'Neal: "I got tired of being a player." Then he added, with a laugh, "And she was the only woman my mom liked."

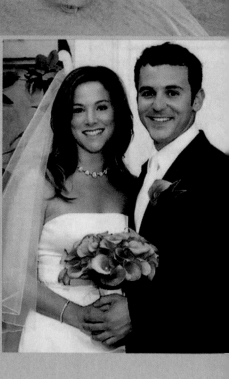

HELLO AGAIN
(Clockwise from top left) Donna Hanover got reacquainted with attorney **Ed Oster** before their college reunion. Fashion designer **Shoshanna Lonstein** knew investment analyst **Josh Gruss** in junior high. *The Wonder Years'* **Fred Savage** grew up with real estate agent **Jennifer Stone** in a small town outside Chicago. *Passions* star **Liza Huber** first met **Alex Hesterberg**, a software executive, in third grade.

REUNITED

SECOND CHANCES YIELD ROMANCES FOR THESE COUPLES WHOSE PATHS CROSSED, PARTED AND MET AGAIN—FOR GOOD

DONNA HANOVER & ED OSTER August 3, 2003

"There is something so promising about reuniting with someone you knew in your youth," Donna Hanover, host of TV's *Fine Living's Homes and Hideaways*, told a reporter. "It's magical." Hanover, whose 18-year marriage to former New York City mayor Rudolph Giuliani ended in July 2002, rediscovered the magic when she reconnected with her college sweetheart Ed Oster. Oster, 52, a California attorney, phoned Hanover, 53, shortly before their 30th Stanford class reunion. The two met for coffee that summer, and come spring 2003 Oster popped the question with a Tiffany 2.5-carat diamond. When the 240 guests, including Susan Lucci, gathered for the ceremony at the Tappan Hill estate in Tarrytown, New York, it was time to party. The celebration's kickoff? A lively performance of "My Boyfriend's Back."

LIZA HUBER & ALEX HESTERBERG March 13, 2004

When it came to his appetite for love and his crush on actress Liza Huber, star of NBC's *Passions* and daughter of actress Susan Lucci, Alex Hesterberg, a managing principal for a West Coast software company, went the extra mile. The pair first met as third graders in Garden City, New York. "I wanted to take her for pizza," said Hesterberg. When serendipity reconnected them two decades later at a 2002 Manhattan concert on Emmy night, Hesterberg was determined to have that meal. "He ended up flying cross-country to take me to dinner," said Huber, who lived in New York. A month later, Hesterberg made another cross-country trip, driving Huber and her golden retriever Charlie to L.A. when she landed her TV role. The couple made the trip down the aisle in front of 300 guests at St. Joseph's Roman Catholic Church in their hometown. Said Hesterberg: "Now I can take her out for pizza whenever I want!"

SHOSHANNA LONSTEIN & JOSH GRUSS May 10, 2003

Though she is known for teeny-weeny bikinis, the fashion designer racked up big numbers during her relationship with investment analyst Josh Gruss, 29. The pair met in junior high, then crossed paths at a party in 2001. "Josh made me laugh 50 times in the first two minutes," said Lonstein, 27. Following Gruss's proposal eight weeks later, he left for two months of boot camp with the Coast Guard Reserve, then reunited with his fiancée at N.Y.C.'s Metropolitan Club with 200 guests. It took 20 people nine hours to assemble an 18-ft.-high chuppah. Lonstein was attended by eight bridesmaids, wore a 30-carat diamond necklace, exchanged four rings with her hubby and selected two bouquets (lilies for photos, roses for the ceremony). In the end, Gruss sang "Just the Way You Are," their favorite song.

FRED SAVAGE & JENNIFER STONE August 7, 2004

We remember the boyish charm of actor Fred Savage from the late-'80s sitcom *The Wonder Years*. But Jennifer Stone, 31, a commercial real estate agent, recalls a time long before the wonderment. The two grew up together in a small town outside of Chicago. They parted ways in 1988, when Savage moved to Los Angeles for the TV show. Eleven years later, when Stone relocated to L.A., they reconnected at the actor-director's 22nd birthday party. "We started talking and smooching, and we've been together ever since," said Savage, 28. On a trip to Italy in September 2003, Savage proposed with a 5-carat cushion-cut sapphire surrounded by pavé diamonds. The couple wed at L.A.'s L'Orangerie restaurant, where, during their vows, Savage read lyrics from Bob Dylan's "If Not for You" and said he promised to "always find the closest parking space, and she promised to never let me dress myself."

*the*RECEPT

The celebration continues with post-ceremony soirées ranging from

"PARTY ALL NIGHT!" DEMANDED THE NEW Mrs. Trump, Melania Knauss, having changed from her wedding gown, as many brides do, into a second, easy-to-dance-in dress for her Mar-a-Lago reception. The sentiment was shared at several celebrity receptions—from the hip-hop afterparty of Nasir "Nas" Jones and Kelis Rogers (where rapper Doug E. Fresh took the stage) to the intimate shabby-chic affair in the backyard tent of wedding planner Alyson Fox for Britney Spears and Kevin Federline (with post-reception clubbing).

But before they danced, they dined. As a gift to the Trumps, Manhattan überchef Jean-Georges Vongerichten created an extravagant menu, including lobster rolls, crab cakes and filet mignon with potato horseradish galette. Nas insisted that his personal favorite, mac and cheese, be part of the fare at his fete, and Spears, true to her southern roots, requested "country food," with peach cobbler for dessert. For some, dinner and dancing is too rote: Russell Crowe's guests had an ABBA sing-along. Adam Sandler provided a mini arcade with Pac-Man, foosball and Xbox machine. Joey Fatone had an entire carnival with Ferris wheel. *Survivor* castmates Amber Brkich and Rob Mariano jumped up calypso-style till the wee hours in the Bahamas, while for *Sopranos* star Jamie-Lynn Sigler, a good time meant the A-listers' version of karaoke—singing "My Funny Valentine" live with Carly Simon.

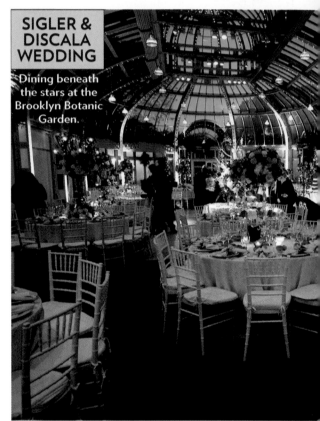

SIGLER & DISCALA WEDDING

Dining beneath the stars at the Brooklyn Botanic Garden.

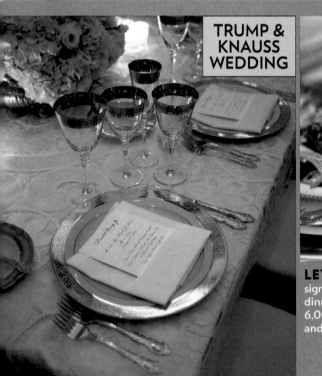

TRUMP & KNAUSS WEDDING

LET THEM EAT SHRIMP Trump's signature color, gold, trimmed the 10-in. dinner plates. Forty-five chefs made 6,000 appetizers, including lobster bites and (above) salad topped with shrimp.

JONES & ROGERS WEDDING

Green douppioni silk dressed tables at an Italian-style villa.

ION

intimate to extravagant

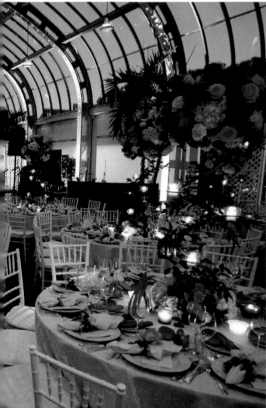

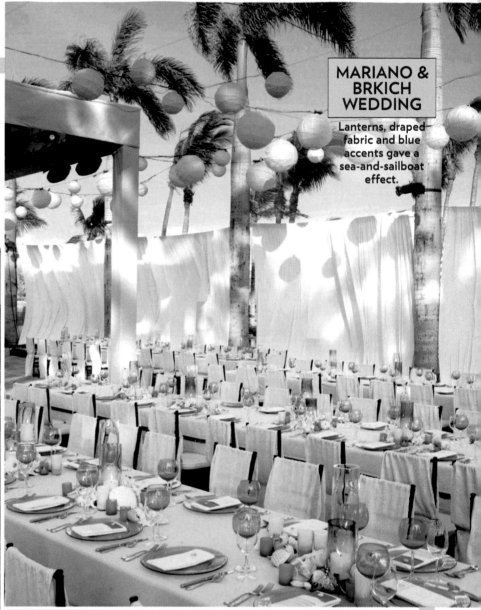

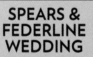

MARIANO & BRKICH WEDDING

Lanterns, draped fabric and blue accents gave a sea-and-sailboat effect.

SPEARS & FEDERLINE WEDDING

Fuchsia, burgundy and red roses atop satin taffeta-covered tables added punch to the white decor.

LIKE PARADISE
Amber Brkich and Rob Mariano fell in love on the way to winning *Survivor: All-Stars* in 2004. Their wedding at the Atlantis Paradise Island resort in the Bahamas was filmed for a TV special.

CHAPTER 9

the REAL DEAL

These reality TV stars found true romance
on-set, behind-the-scenes and with longtime sweethearts,
and tied the knot—in style

SURVIVOR ALL STARS
rob mariano & amber brkich

APRIL 16, 2005 Forget survivors—Mariano and Brkich are serious overachievers. On CBS's *Survivor* series, Mariano, 29, holds the record for most wins (16 challenges). Not to be topped, Brkich, 26, won *Survivor: All-Stars* and collected $1 million. Better still, during the *All-Stars* finale, Mariano proposed to Brkich. The couple sealed their alliance with a romantic beach ceremony at the Atlantis, Paradise Island resort in the Bahamas with 230 guests, 11 groomsmen, 8 bridesmaids and a swarm of TV crews. (CBS aired the ceremony May 24.) Still, the day was all about the happy couple. Brkich walked down the aisle in an Arlette Kronk gown. Her groom awaited her in a cream Tommy Bahama suit. "You might have started out as competitors, but today you stand side by side as each other's truest friends," said minister J.P. Reynolds. After the honeymoon, the tag team planned to enjoy the three trips they won during their run on *The Amazing Race*. Said Brkich: "I can't imagine our life ever being boring."

One of eight bridesmaids with flower girl Emma Pavelek, Amber's niece.

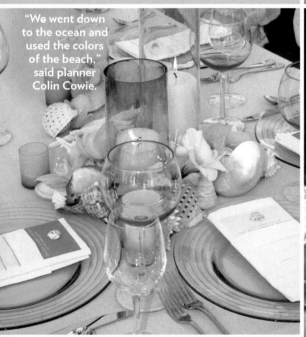

"We went down to the ocean and used the colors of the beach," said planner Colin Cowie.

The local Junkanoo band.

The couple penned the vows themselves for the beach ceremony at sunset. "I've never met anyone who made me feel so special," said Rob. "I promise to always be true to you."

THE APPRENTICE
sam solovey & lori levin

AUGUST 15, 2004 Even though he compared getting canned by Donald Trump with being "shot between the eyes," nothing seemed to slow down 28-year-old Sam Solovey, an early casualty on the first season of *The Apprentice*. Just one day after the January 21 airing of his final bizarre foul-ups and the ultimate tossing from the boardroom, Solovey, cofounder of an Internet newsletter business, proposed to his girlfriend of 5½ years, fifth-grade schoolteacher Lori Levin, during a live airing of NBC's *Today* show. While sitting next to Levin and chatting it up with Katie Couric, the self-described "wild man" came across as quite the romantic when he dropped to one knee and said, "I may have lost on last night's episode, but I will win today and we will win every day if you spend the rest of your life with me. Will you marry me?" Levin, 26, immediately accepted and remarked, "He does things big, I'll say." As for the wedding, Levin said she was determined to keep it grounded. She told a *Washington Post* reporter, "[Sam] likes things big, and I like things simplistic and realistic. That's where the balance comes in." The couple kept it real with a traditional Jewish ceremony at Washington, D.C.'s Mayflower hotel surrounded by 200 loved ones—no TV cameras, no castmates. Said Solovey: "It's a wedding, and you want it to focus on you, and especially on the bride." Of his new missus, he said, "She brings out the best in me."

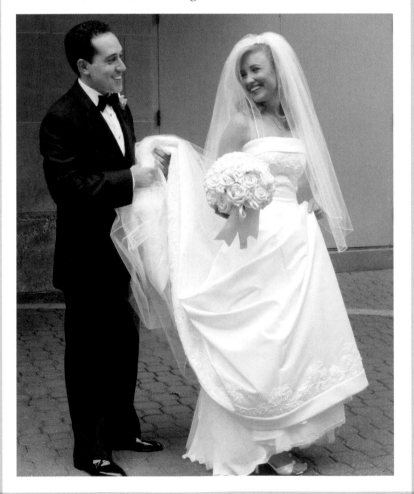

THE BACHELORETTE
trista rehn & ryan sutter

DECEMBER 6, 2003 Boy meets girl, falls in love, proposes and gets married. The exception here? Rehn, 31, and Sutter, 29, of ABC's *The Bachelorette*, both courted and married in front of millions of dedicated TV viewers. The nuptials took place at the Lodge at Rancho Mirage in Palm Springs Valley, California, and included 30,000 roses, a seven-tier cake, a pair of Stuart Weitzman bridal shoes encrusted in diamonds and two Badgley Mischka creations. Still, they were just an everyday couple in love. Sutter told a reporter, "When I asked [Trista] to marry me at the end of *The Bachelorette*, I would have been ready in a week." The firefighter later added, "I'd have married her without any of this." Said Mrs. Sutter, a former physical therapist: "I would have too."

Rehn changed into a lace dress to cut the Cake Divas cake, adorned with 1,000 sugar roses.

Rehn gets help from bridesmaids to get into her first Badgley Mischka gown.

Just one of the 17 million people who watched the nuptials.

THE APPRENTICE
katrina campins & ben moss

AUGUST 14, 2004 Surely, if they could face The Donald week after week, *The Apprentice* alums could withstand 2004's Hurricane Charley. And so they did, traveling to Florida for castmate Campins, 24, and her real estate broker boyfriend Ben Moss, 26. The couple tied the knot, appropriately enough, at Trump Sonesta Beach Resort outside of Miami. Decked in $1.5 million of loaned jewelry, the bride wore a Vera Wang gown and walked barefoot down an aisle of indoor grass. "The wedding was to the point and elegant," said a businesslike Omarosa Manigault-Stallworth. "It's the most romantic wedding I've seen," said a more sentimental Heidi Bressler, "and I've been to weddings!" As for Campins, she looked forward to showering her new husband with love. "He's the best in the world," she said, "my calm in the storm."

matt rogers & teri himes

FEBRUARY 19, 2005 When Teri Himes, a mortgage processor, interviewed for a job where Matt Rogers worked, the *American Idol* alum told his boss, "Hire her." Not only did Himes, 26, get the job, she got the man. Rogers, 26, popped the question at a restaurant in Laguna Beach, with family, friends and TV show *Extra* on hand to capture the moment (though it never aired). "Teri said yes, which was good . . . the 5.5 carats helped," said Rogers. Surrounded by 383 guests at the Huntington Beach Hilton, the bride entered to Shania Twain's "From This Moment On," sung by *American Idol* runner-up Diana DeGarmo. "I've played football in the Rose Bowl with the University of Washington in front of hundreds of thousands of people, and sang onstage in front of millions, but never have I been so nervous," said Rogers. "She looked beautiful."

kacie searcy *&* james bower

NOVEMBER 27, 2004 They nipped, they tucked, they tied the knot. Then the newly transformed Kacie Searcy, 22, and James Bower, 24, who met in February 2004 as cosmetic surgery patients on ABC's *Extreme Makeover,* exchanged self-penned vows in front of about 50 guests at Main Street Restaurant in Yorba Linda, California. With breast implants, two nose jobs, two chin implants, a scar removal (him) and tattoo removal (her) behind them, the couple looked forward to their beautiful lives together. Said the bride, five months pregnant with their son: "I don't know if it's the pregnancy or the makeover or James, but I feel pretty."

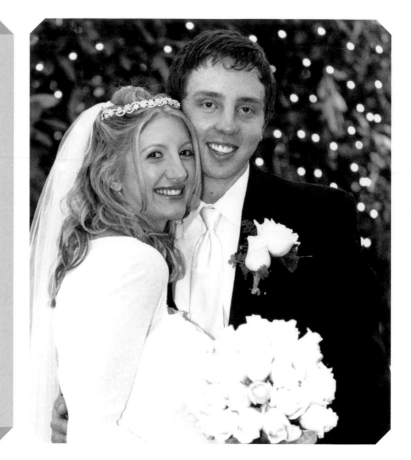

JITTERS
THE BEST-LAID PLANS ARE SUBJECT TO CHANGE

◆ Hurricane Hernan, boiling up in the Pacific, forced **Sarah Michelle Gellar**'s nuptials to longtime beau **Freddie Prinze Jr.** indoors, from the beach to a villa in Mexico. The next day, a 4.6 Richter-scale earthquake rattled the crystal.

◆ *Sopranos* star **Jamie-Lynn Sigler** takes the cake. The week before her wedding to her manager **A.J. DiScala** in Brooklyn, she sprained her ankle in a basketball game. Hobbling in her platform heels, she then weathered a torrential downpour on the way to the altar. On her way down the aisle, she learned her brother was locked in the bathroom—with the rings. He emerged after 10 tense minutes. Finally, a volcanic eruption on the Caribbean island where the couple were to honeymoon forced a change of plans to Florida.

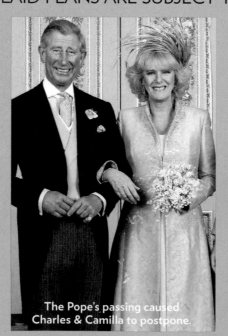

The Pope's passing caused Charles & Camilla to postpone.

◆ With the death of Pope John Paul II, the long-awaited wedding of **Prince Charles** and **Camilla Parker Bowles** was moved by one day to April 9, to enable Charles and some guests such as Britain's Prime Minister Tony Blair to attend the Pope's funeral.

◆ A storm caused an electrical outage during Corrs drummer **Caroline Corr**'s nuptials to Dublin property developer **Frank Woods** in Majorca, Spain. The power came back on while they said I dos.

◆ At the wedding of Spain's **Crown Prince Felipe** in Madrid, a thunderstorm deluged the city just as bride **Letizia Ortiz** was to begin her red-carpet walk to the cathedral. The king and 1,400 guests were forced to wait 15 minutes until a Rolls-Royce picked her up and whisked her to the ceremony.

bob guiney & rebecca budig

JULY 3, 2004 Although *The Bachelor*'s Bob Guiney, 33, chose Estella at the end of his season, it was *All My Children* actress Rebecca Budig, 31, who got him to the altar. The couple held an outdoor ceremony near Guiney's family's Long Lake, Michigan, cottage in front of 50 family and friends. In true Bachelor Bob fashion—laid-back and low-key—the pair decided not only to keep the wedding a secret (Guiney's mom didn't know about the ceremony until the day before), but to keep it as relaxed and casual as possible. Wearing an open-neck shirt and cargo pants, the reality star and his sweetheart exchanged I dos, followed by water sports and chicken-and-ribs barbecue. "They're very happy," said Budig's mother. "They were kissing and smiling" throughout the wedding.

MTV WEDDINGS

Following the beat of their hearts, rappers and rockers let love rule and put on a great show for the big day

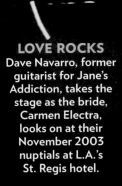

LOVE ROCKS
Dave Navarro, former guitarist for Jane's Addiction, takes the stage as the bride, Carmen Electra, looks on at their November 2003 nuptials at L.A.'s St. Regis hotel.

jessica simpson & nick lachey

OCTOBER 26, 2002 Before they became TV's most popular *Newlyweds,* Nick Lachey and Jessica Simpson were simply two singers in love. The couple met in pop-star fashion at the 1998 Hollywood Christmas Parade, then fell in love weeks later at a TEEN PEOPLE party. They had a falling out for a few months in 2001, then fell back in after September 11. After their engagement in February 2002, a then 22-year-old Simpson wrote on her Web site, "He had been patiently waiting for me to grow up."

Later that year, the pair had a grown-up wedding with about 350 guests at Riverbend Church in Austin, Texas. Lachey's brother Drew served as best man, and Simpson's teen sister Ashlee served as maid of honor. A pre-Daisy-Duke Simpson said she stayed true to her "down-home southern self" by planning the wedding, which included a Baptist ceremony led by minister Brian Buchek, a friend since fifth grade, and a 25-voice choir singing "Joyful, Joyful, We Adore Thee" and "Oh Happy Day." The beaming virgin bride wore a beaded, strap-less Vera Wang gown and carried a 500-stem stephanotis bouquet from Mark's Garden in L.A. that took 12 hours to assemble. The groom wore Hugo Boss.

In addition to the vows, the duo wrote songs for each other. Lachey, 28, got choked up singing "My Everything" for his bride, while Simpson, said to be much sharper than the "dumb blonde" persona she portrayed on MTV's *Newlyweds: Nick and Jessica,* took the safer way out and mouthed the words as a friend sang "My Love," a song Simpson penned for her groom. At the candlelit reception at the Barton Creek resort, guests feasted on lobster bisque, spinach salad and lemon-thyme chicken. The couple danced their first dance to "Crazy Love," performed by country singer Neal McCoy. "I can't wait to dance with my daddy," said the bride, who took a spin with her manager father, Joe, to Van Morrison's "Brown Eyed Girl." Said Bill Browder, a guitarist in the Big Time, a local band hired for the bash: "They were just like regular people, except prettier and richer."

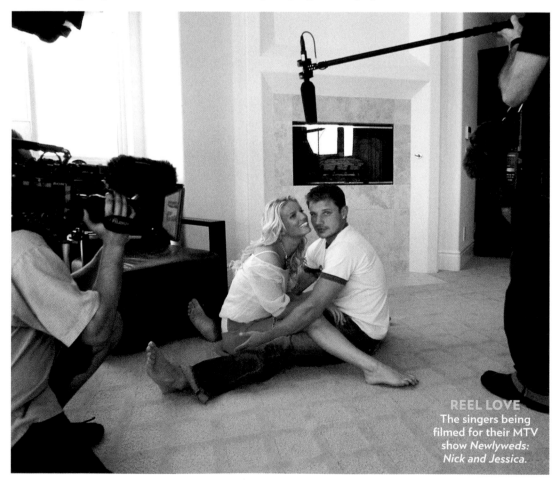

REEL LOVE
The singers being filmed for their MTV show *Newlyweds: Nick and Jessica.*

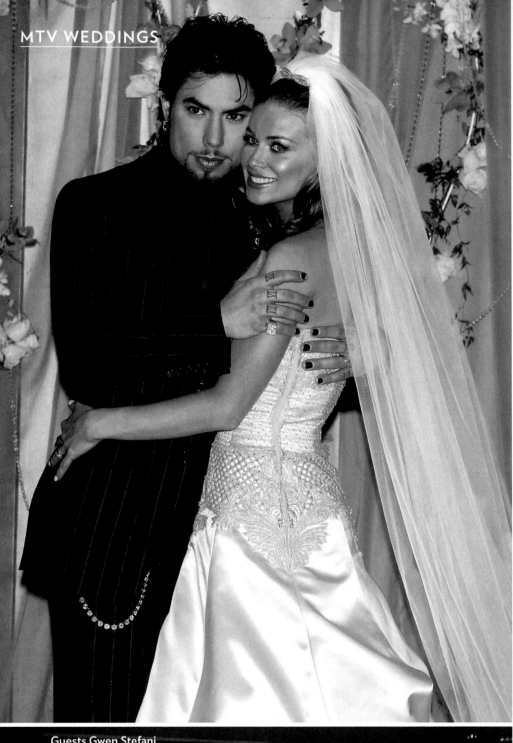

carmen electra & dave navarro

NOVEMBER 22, 2003 "It was unlike anything I've ever been to," former Jane's Addiction guitarist Dave Navarro said of his red-and-black-themed wedding to actress and dancer Carmen Electra. "I didn't know what was around each corner."

The couple's big day at the St. Regis hotel in L.A. was chock-full of eccentric touches—with 200 guests greeted by masked doormen dressed in black (a nod to one of the couple's favorite films, *Eyes Wide Shut*), plus cockatoos, children dressed as fairyland sprites, and "cocktails" in atomizers that wedding-goers spritzed into their mouths—all before reaching the room where the ceremony would take place. The Garden of Eden environment came complete with projected water walls and a white python. Infused with the surreal elements, however, were the traditionally touching moments. As the ceremony got under way at 5:30 p.m., Electra, 31, told a friend, "What's really going to touch my heart is when my dad takes a step back when walking down the aisle and my husband takes his place."

"I'm marrying the girl of my dreams," said Navarro, 36, who watched his bride enter via an Oz-like winding ivory carpet wearing a strapless beaded Badgley Mischka gown. The couple, who met on a blind date, exchanged self-penned vows, during which Electra joked, "I thought I would never marry a guy who looks in the mirror more than I do." Following a lively reception—filled with pinball machines, a fortune-teller's booth and sushi servers dressed as conjoined twins—Mrs. Navarro declared, "This was the most beautiful day of my life."

Guests Gwen Stefani and Kelly Osbourne, daughter of bridesmaid Sharon, check out the white python in the Garden of Eden.

Playboy's Hugh Hefner celebrates with the bride.

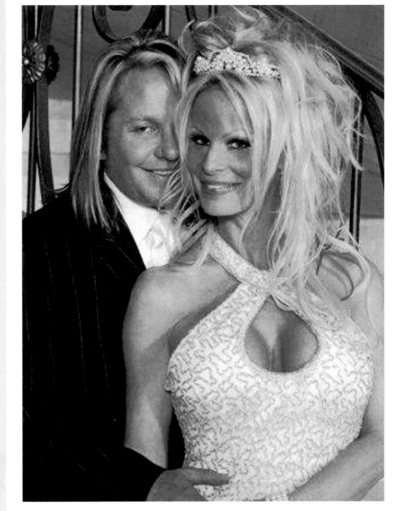

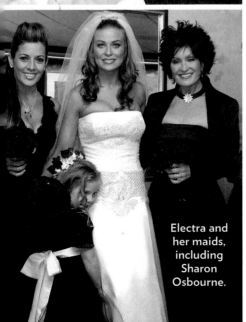

"The only thing I noticed was the sparkle in Carmen's eyes," said the groom.

Electra and her maids, including Sharon Osbourne.

vince neil
& lia gerardini

JANUARY 9, 2005 It's hard to imagine the softer side of legendary hard rockers. But the Las Vegas nuptials of rock & roller Vince Neil, 43, and girlfriend Lia Gerardini, 37, moved the lead singer and his Mötley Crüe to tears. "Everybody was crying!" said Neil. "I started crying, Tommy Lee started crying. Then everyone just lost it. It was sentimental, very heartfelt." Luckily, rapper-turned-minister MC Hammer was on hand, not only to wed the couple for her second marriage and Neil's fourth but to bring a little levity to the day by declaring "It's Hammer time!" as he escorted the groom down the aisle. The pair became good friends when they shared a house as costars of VH1's *The Surreal Life*. Said Neil of his officiant: "He was going to be at the wedding anyway, so we figured why not just have him do it." The reception rocked on in a Four Seasons ballroom that was converted into a nightclub. The leopard-skin furnishings of the loungelike setting no doubt suited wildmen Nikki Sixx, Dennis Rodman and *Baywatch* cocreator Michael Berk among the 150 guests. Says Gerardini, who met Neil at a concert seven years ago: "The wedding was just like Vince and I—very romantic with a touch of rock and roll."

$4 MILLION

Trista Rehn and Ryan Sutter wed at the Lodge at Rancho Mirage in Palm Springs Valley, Calif.

$1 MILLION

Tori Spelling and Charlie Shanian under the floral chuppah at Aaron Spelling's.

$45 MILLION

Donald Trump and Melania Knauss did it up at Mar-a-Lago, Trump's Palm Beach estate, in January 2005. He spent $45 million just to build the ballroom where the reception was held.

MILLION DOLLAR WEDDINGS

LOVE IS PRICELESS, BUT FOR THESE STARS, THE BIG DAY WAS THE ULTIMATE INDULGENCE

Billionaire **Donald Trump** outspent them all, as usual, and forked over $45 million just to gild the lily—or rather the ballroom—that would hold the wedding of the year. That was before counting the expense of a small legion of chefs, the cargo trucks of flowers, the cake with 3,000 sugar roses, the $100,000 dress and the 1983 Cristal at $650 a pop. But what do a few appetizers of beggar's purses for 500 cost these days? (If you're planning, that's $18,000—for the Beluga caviar, not counting the potatoes.)

Aside from **Trista** and **Ryan**'s $4 million extravaganza (which they agreed to share with 17 million viewers in exchange for ABC footing the bill), there were a few runners-up. The June 2002 nuptials for 300 of **Sir Paul McCartney** and

$1 MILLION

Pierce Brosnan and Keely Shaye Smith celebrated at Ashford Castle in Ireland.

Heather Mills cost $3.2 million. The fete took place at a castle in Ireland and featured imported 14-inch gold-leaf plates, thousands of flowers from Holland, an R&B band from New Jersey, an Indian-themed vegetarian feast and around 100 private security guards from Scotland—many of them former British soldiers and vets of the **Madonna-Guy Ritchie** wedding.

Speaking of which, the kabbalah devotees didn't divulge costs for their Skibo Castle nuptials in December 2000, but put their 70-man detail to good use. The couple had all 51 rooms booked for five days for their 55 guests, such as **Gwyneth Paltrow**, **Sting** and **Stella McCartney**, and threw lavish dinner parties including the wedding night banquet of langoustines, angus beef and Beaujolais, with a cake flown in from London.

Pierce Brosnan spent $1 million on his castle celebrations, but made a large donation to help a school for Tibetans in Nepal, while flowers and a portion of the cake went to a local home for seniors. **Tori Spelling** and **Charlie Shanian** got married at her father's house, but that didn't make it any cheaper, coming in at $1 million. **Jessica Simpson** said her October 2002 nuptials in Austin cost $200,000 and "left us bankrupt." Simpson later released *I Do: Achieving Your Dream Wedding,* a book and DVD on how to get hitched on a budget. Too bad, carped husband **Nick Lachey**, "we didn't have any of that wisdom."

HIGH NOTES

STARS TAKE A SPIN, SING A TUNE, SERENADE EACH OTHER AND STRAIGHT UP JAM TO MARK THE SPECIAL OCCASION

FIRST DANCE

◆ **Britney** and **Kevin Federline**, "Lights" by Journey
◆ **Denise** and **Charlie Sheen**, "Open Arms" by Journey
◆ **Donald** and **Melania Trump**, "Nessun Dorma" by Puccini
◆ **Jessica** and **Nick Lachey**, "Crazy Love" by Van Morrison
◆ **Dave Navarro** and **Carmen Electra**, "By Your Side" by Sade
◆ **Melissa Etheridge** & **Tammy Lynn Michaels**, "My Girl"
◆ **Star Jones** and **Al Reynolds**, "Fly Me to the Moon"
◆ **Kevin** and **Christine Costner**, "Unchained Melody"
◆ **Wynonna Judd** and **D.R. Roach**, "Over the Rainbow"
◆ **Pierce Brosnan** and **Keely Shaye Smith**, "If I Should Fall Behind" by Bruce Springsteen
◆ **Shaquille O'Neal** and **Shaunie Nelson**, "This Ring"
◆ **Katey Sagal** and **Kurt Sutter**, "Cannonball" by Damien Rice

THE GIFT OF SONG

◆ **Billy Joel** performed a montage of hits during a 90-minute set, plus sang "Try a Little Tenderness" for his bride.
◆ **Russell Crowe** jammed with band 30 Odd Foot of Grunts.
◆ **Jamie-Lynn Sigler** sang "My Funny Valentine" with Carly Simon and a solo of "Someone to Watch Over Me."
◆ **Adam Sandler** performed an original ditty for **Jackie Titone.**
◆ **Tom Arnold** sang "Johnny B. Goode" with 'N Sync's Chris Kirkpatrick at his reception.
◆ **Dave Navarro** rocked with Donovan Leitch at Navarro's wedding with **Carmen Electra.**
◆ **Charlie Shanian** performed "I Love You, Crazy," a tune written by his pals, for **Tori Spelling** at the couple's rehearsal dinner.
◆ **Heather Mills** serenaded Paul McCartney with "God Only Knows" by the Beach Boys.

PARTY ON *Sopranos* star Jamie-Lynn Sigler in a duet with Carly Simon, a friend of groom A.J. DiScala's, with "My Funny Valentine."

gwen stefani & gavin rossdale

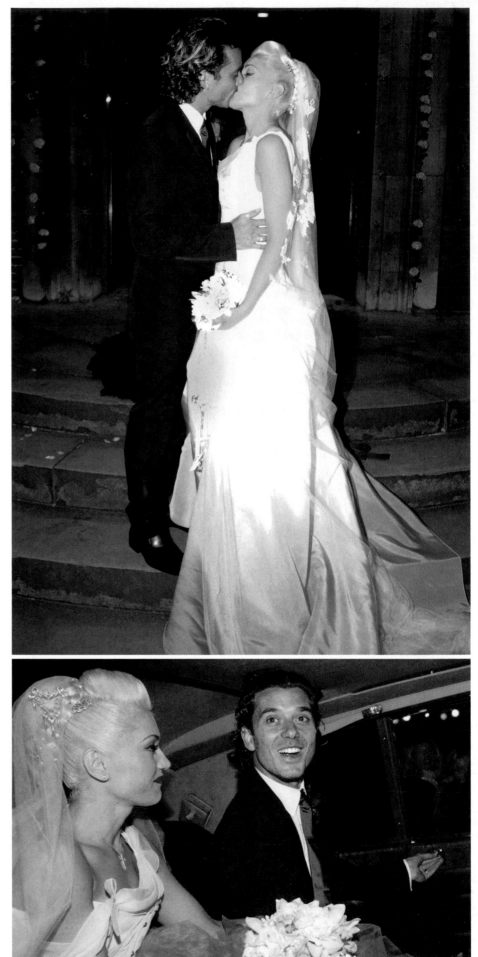

SEPTEMBER 14, 2002 Who would guess that wild child Gwen Stefani would be a bride who left nothing to chance? When the No Doubt singer's longtime boyfriend, former Bush frontman Gavin Rossdale, 34, proposed to her on New Year's Day in 2002 (after first asking her father for her hand in marriage), Rossdale said his fiancée, whom he met when their bands toured together in 1995, "knew what she was wearing [to the wedding] five days later." The style icon's choice? A custom-made Dior by John Galliano silk faille gown and antique lace veil. "She looked unbelievable," said one guest.

Instead of depending on Mother Nature to put a twinkle in the sky, Stefani, 32, had sparkly stars strung from trees across the 17th-century churchyard at St. Paul's Covent Garden in London. And perhaps to ensure that all 150 guests had time to get in their places, the bride arrived at the church in a 1970 Rolls-Royce an hour late, clutching rosary beads and her grandmother's Catholic prayer book. A piper soothed waiting guests with a medley including "Amazing Grace."

Meanwhile, Rossdale quelled his pre-wedding jitters downing beer and sausage sandwiches at a local pub. His good-luck talisman? Beloved Hungarian sheepdog Winston, attired in a collar of flowers, was at his side throughout the ceremony. Said Galliano: "The roses, the twinkling stars, the service—it was very romantic. She cried, he cried—and so did the dog!" Two weeks later the couple captured the magic again, this time with a Catholic blessing in Los Angeles.

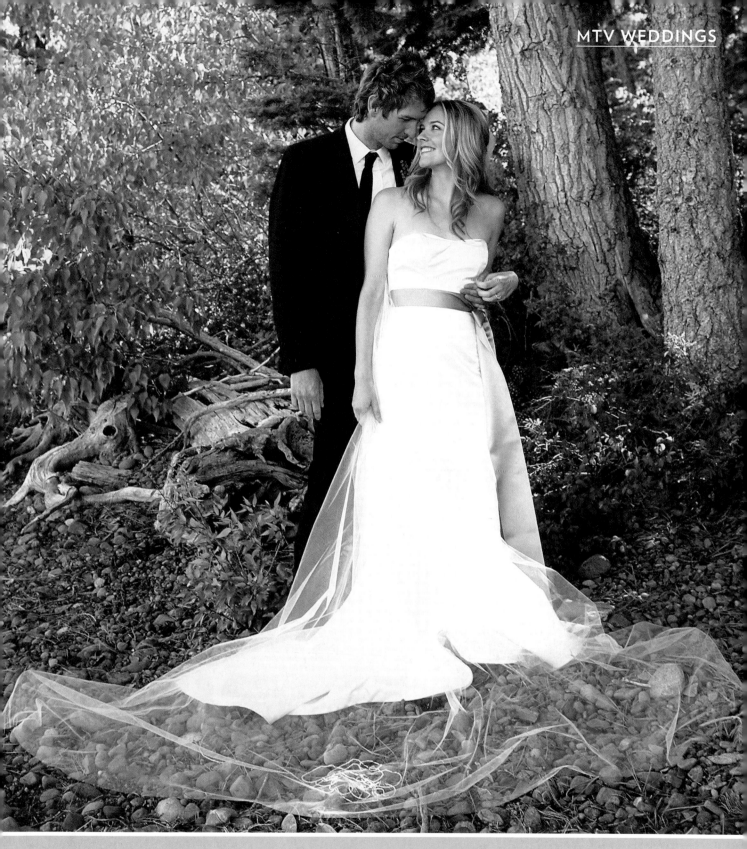

alicia silverstone & christopher jarecki

JUNE 11, 2005 The au naturel flavor of the wedding of actress Alicia Silverstone, 28, and neopunk band S.T.U.N.'s frontman Christopher Jarecki, 34, was very much by design for the strict vegans (no dairy, fish or meat). Jarecki and the *Clueless* star, who have been together for eight years and share a home that includes an organic vegetable garden and a brood of rescued dogs, were on the same recycled page for the Lake Tahoe, California, nuptials: The agreed-upon touches included recycled invitations, organic beeswax candles, a bar made out of old wine barrels and bamboo chairs for the couple's guests, including actor Woody Harrelson and his wife. The newlyweds danced until 1:30 a.m. Said Silverstone: "It was amazing to be surrounded by people you love most, all gathered in one place."

travis barker & shanna moakler

OCTOBER 30, 2004 Blink-182's heavily tattooed drummer Travis Barker, 28, made his Halloween Eve ceremony at Santa Barbara, California's Bacara Resort and Spa a little bit spooky, but mostly sweet, when he wed former Miss USA Shanna Moakler, 29. The gothic-style red-and-black affair for 250 was inspired by the couple's favorite flick, Tim Burton's *The Nightmare Before Christmas,* and featured the couple's 1-year-old son Landon in a mini version of Daddy's tux and Mohawk. Moakler's daughter Atiana, 5, from a previous relationship with boxer Oscar De La Hoya, served as a flower girl. Said Moakler: "Even though it was different and wild, it was really upscale and romantic. It was like a fairy tale." MTV has doc'd the happy couple's free-spirited and romantic antics on the new "newlywed" show *Meet the Barkers.*

nasir jones & kelis rogers

JANUARY 8, 2005 Rapper Nas, a.k.a. Nasir Jones, is known for delivering in-your-face rhymes crafted with thought-provoking metaphors. But when the multi-platinum-selling rap artist was introduced to R&B singer Kelis Rogers at an MTV Video Music Awards party in 2002, he got straight to the point. "I told her I was going to marry her," Nas, 31, told a reporter. He said it and meant it, and in January Nas and Kelis exchanged self-written vows at Atlanta's Morning-side Baptist Church in front of 175 guests. Kelis, 25, whose eccentric sense of style translates into vivid hair colors, wanted a poison ivy theme—hence her Matthew Williamson gown in various shades of green. "I'd never known Nas to smile," said wedding planner Diann Valentine. "But when Nas is with Kelis, you see him smiling and laughing all the time."

FAMILY AFFAIR

From little babes to lil' bowwows, these loved ones helped fill the occasion with relative joy

WHEN IT CAME TO THE BIG DAY, THESE COUPLES LEFT NO family (furry or otherwise) out of the picture. Adam Sandler's bulldog Meatball and one pooch of Tori Spelling's pair played ring bearer. Winston, Gavin Rossdale's sheepdog, was at the rocker's side as he exchanged vows with Gwen Stefani (but was spared from remembering a ring or a speech). Dennis Quaid included his five dogs at his nuptials and made son Jack Henry, 12, best man. At Diane Lane and Josh Brolin's intimate do, Lane's daughter Eleanor, 11, and Brolin's daughter Eden, 11, and son Trevor, 16, served as attendants. Gena Lee Nolin's 7-year-old son Spencer stepped up to the task of walking Mom down the aisle, while *Apprentice* producer Mark Burnett's son Cameron met the pressure of presenting rings at the Trump extravaganza. But Len Wiseman gave Kate Beckinsale's daughter Lily, 5, a ring and asked her to marry him too. Undoubtedly, Lily accepted.

SHANNON & CHESNUT WEDDING The couple's 8-month-old Stella.

ELECTRA & NAVARRO WEDDING

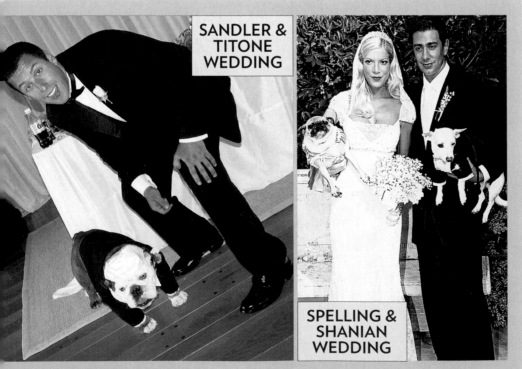

SANDLER & TITONE WEDDING

SPELLING & SHANIAN WEDDING

GOIN' TO THE DOGS Meatball struck a pose with big daddy; Spelling and Shanian's flower girl (left) and ring bearer (right) donned a mini bridesmaid's dress and tux.

BARKER & MOAKLER WEDDING

Moakler was attended by six flower girls, including her daughter Atiana.

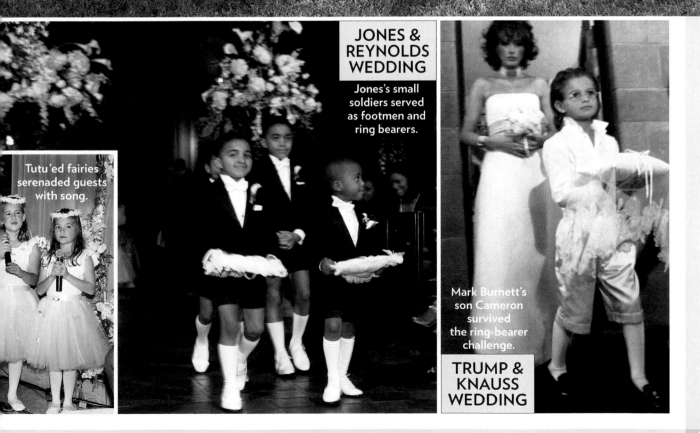

JONES & REYNOLDS WEDDING

Jones's small soldiers served as footmen and ring bearers.

Tutu'ed fairies serenaded guests with song.

Mark Burnett's son Cameron survived the ring-bearer challenge.

TRUMP & KNAUSS WEDDING

MARRIED IN the MOVIES

From killer brides and grooms to fairy-tale
princes and princesses, nuptials played out onscreen
explore the quest for true love

CAREER BRIDE

Jennifer Lopez looks the part of a beautiful bride both onscreen and off. In real life, she's been married three times (almost four, if you count the near-nuptials to Ben Affleck). Cinematically speaking, she has at least matched that number, including a *Jersey Girl* flashback "I do" with Affleck that wound up on the cutting room floor around the time their relationship wrapped. In two of her other movie marriages, Lopez is a sweet-but-tough working girl with a scrappy screen name whose choice of husbands has her on the defensive. Her Charlotte "Charlie" Cantilini temps, walks dogs and then comically faces off against snarling *Monster-in-Law* Jane Fonda, who thinks her unsuited to surgeon son Kevin (Michael Vartan). As Slim, Lopez trades waitressing for love and motherhood with rich contractor Mitch (Billy Campbell) but orders up martial-arts training when she's had *Enough* of his abusive behavior. Her successful *Wedding Planner* persona, Mary Fiore, finds unexpected love with Steve, a client's M.D. fiancé (Matthew McConaughey). In fact, Mary sounds like the kind of professional Lopez might have tapped for her own surprise nuptials to Marc Anthony in June 2004.

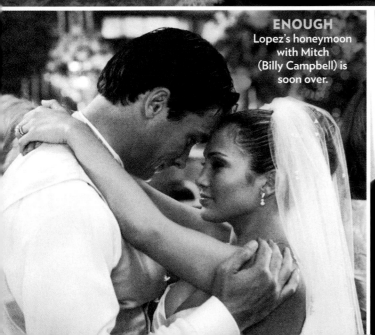

MONSTER-IN-LAW
As Charlie, Jennifer Lopez trades slaps and barbs with Monster Jane Fonda.

ENOUGH
Lopez's honeymoon with Mitch (Billy Campbell) is soon over.

THE WEDDING PLANNER
As Mary, she's all set to marry Massimo, but grooms can change.

THE PEOPLE VS. LARRY FLYNT

Courtney Love's sad-eyed sexiness took center stage when she got married. The rocker is still known as the widow of Nirvana singer Kurt Cobain, who killed himself in 1994. But her 1996 film turn, as the wife of *Hustler* publisher Larry Flynt, helped distance her from that real-life loss with award nominations and a higher profile. In *The People vs. Larry Flynt,* Love portrays Althea Leasure, the stripper and flamboyant fourth wife of Flynt (Woody Harrelson), the man who takes on Jerry Falwell and free speech. They marry for better (Bel-Air excess), worse (Flynt's paralyzed in an assassination attempt) and in sickness (drug addiction). Love's a still-single mom to Frances Bean, her daughter with Cobain.

AMERICAN WEDDING

American Wedding—the third helping of *American Pie* movies—is something old, borrowed and blue. The latter's the shade of humor in this 2003 film, directed by Jesse Dylan. Bob's son takes some original *Pie* actors (Jason Biggs, Alyson Hannigan, Seann William Scott, Eugene Levy) and ingredients from the original comedy recipe (gross-out gags) and cooks until these *Pies* are done. Jim (Biggs), whose fling with a tart (albeit baked) committed the first *American Pie* to audience memory, is now a college graduate and ready to marry girlfriend Michelle (Hannigan). The prenup yuks involve indecent proposals, bared behinds, bridesmaid-obsessed buddies and bachelor-party hijinks.

MR. & MRS. SMITH

The couple, played by Brad Pitt and Angelina Jolie, meet, marry and move into suburban perfection and routine. Five years on, they're arguing about curtains, talking to a therapist and realizing their relationship's built on lies. Theirs are carpool-crashing whoppers: The Smiths are competing assassins. The movie's peppered with gunfire, jokey asides about minivans and a mutual attraction that approaches Sensurround. Rumors of a real Pitt-Jolie romance were fueled months before the movie's June 2005 release, with the January split between Pitt and Jennifer Aniston, who announced their separation "after seven years together," most as husband and wife. Speculation on Pitt and Jolie's courtship then followed the pair to rendezvous in exotic locales. After the movie's debut, they appeared ready to adopt new identities as a non-covert couple. Jolie also adopted a baby girl as sister to older brother Maddox.

BREAKING UP

Russell Crowe's hotheadedness dates back to his pre-*Gladiator* days, and to a very different arena. In *Breaking Up* (1997), he's Steve, a New York City photographer who's hot for teacher Monica (Salma Hayek). The film's a flashback to their temperamental but passionate pairing, marked by heated fights and steamy nights. A break in the battle comes in one scene where the lovers are dressed to wed. "Think of all the great movie romances," says Crowe. "This is not like those films." In real life, the heart-stopping Hayek's no schoolmarm. She's stunningly single, though previously linked to actors Edward Norton and Josh Lucas. Crowe married fellow Aussie Danielle Spencer in 2003. His desire to speak to his wife long distance led to an infamous phone-throwing incident at a Manhattan hotel during the publicity tour for *Cinderella Man*—a movie that proves he's still got the fight in him.

MY BEST FRIEND'S WEDDING

Julianne Potter (Julia Roberts) is a food critic who gets a matrimonial craving for college fling Michael O'Neal (Dermot Mulroney) when he announces his nuptials to heiress Kimmy Wallace (Cameron Diaz). Julianne's editor, George Downes (Rupert Everett), is sous-chef in a scheme-filled soufflé. There's no such scrambling with Roberts, married since 2002 to cameraman Danny Moder and mother to twins Phinnaeus and Hazel, born in November 2004.

KILL BILL VOL. 2

Here comes the Bride, again. In *Kill Bill Vol. 2*, Uma Thurman renews her *Kill Bill Vol. 1* vows to get back at those who made her wedding rehearsal a bloody mess. Quentin Tarantino's saga marries comics and kung fu, with Thurman as wounded woman Beatrix Kiddo pitted against David Carradine as ex-boyfriend and title target Bill. In *Vol. 1*, the Bride awoke in a vengeful mood after a four-year coma. In *Vol. 2*, the movie rewinds to the deadly rehearsal where Bill's wedding band of assassins lets loose, with her "roaring rampage," as she describes it, finally zeroing in on the showdown with her beloved target. While Thurman underwent a grueling physical transformation to master the Bride's martial moves, her personal moves proved to be just as tricky. *Vol. 2* marked Thurman's return to single status, following her split from Ethan Hawke. She and Hawke, married since 1998 and parents of two, announced their separation in 2003. The agile actress loves her job but calls working motherhood "a very difficult balance."

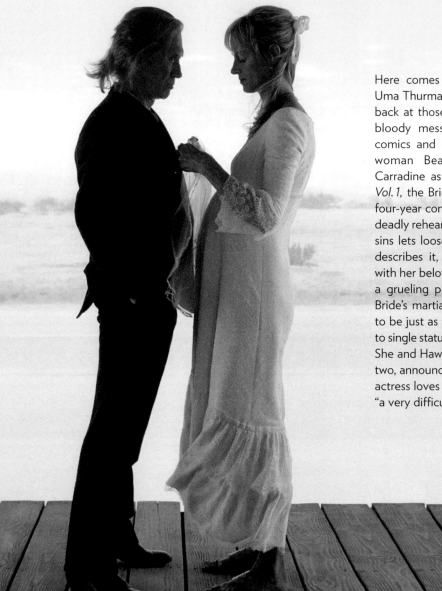

MY BIG FAT GREEK WEDDING

The Greek gods smiled on *My Big Fat Greek Wedding*—as did backers Tom Hanks and Rita Wilson, who spotted the one-woman play by Nia Vardalos and decided it was movie-worthy. The 2002 story of Toula Portokalos, a waitress in her family's Chicago restaurant (her parents want a short-order end to her singlehood), sent Vardalos to the celebrity pantheon. The plot's as old as Athens: Toula's love for non-Hellenic high school teacher Ian (John Corbett) transforms her and trumps Olympic obstacles. Vardalos, married to a real-life Ian (actor Ian Gomez) and for whom this *Wedding* is semiautobiographical, called its surprise success "a fairy tale."

JUST MARRIED

Ashton Kutcher and Brittany Murphy are young newlyweds in *Just Married,* a 2003 comedy with a sweeter sequel: a brief but real-life romance for the leads. In the film, Kutcher and Murphy play regular guy and rich girl whose European honeymoon provides an if-it's-Tuesday-it-must-be-mayhem itinerary that showcases Kutcher's gangly gorgeousness. Their sightseeing continued offscreen, where Kutcher's mom once described the pair, both in their 20s, as "always holding hands, goofing around, wrestling around on the floor the way people in love do." By mid-2003, their travel plans had changed. Murphy's since been engaged but is still dating. Kutcher headed to love with older actress Demi Moore—and they've been acting like honeymooners ever since.

BEWITCHED

Nicole Kidman gets twitchy in the 2005 return of *Bewitched*. Writers Nora and Delia Ephron have stirred a comic cauldron, using ingredients from a familiar '60s sitcom and adding some modern, inside-showbiz spice. Kidman's Isabel Bigelow (like her TV predecessor Samantha Stephens) is a real witch living among unwitting mortals in Los Angeles. She's also got a similarly nimble nose—which when spotted by actor Jack Wyatt (Will Ferrell), looking to cast a *Bewitched* remake, gets her the Samantha role. Wyatt takes the part of Samantha's hapless husband, Darrin. Amidst Isabel's spells, some real sparks start to fly between the castmates. Offscreen, the hypnotic Kidman has been actively single since her marriage to fellow actor Tom Cruise ended in 2001. In spring 2005, when Cruise began acting bewitched by actress Katie Holmes (to whom he later proposed), Kidman didn't raise her wand: "Listen—honestly, if Tom's in love, I'm so happy for him."

DR. T AND THE WOMEN

Richard Gere is a dapper Dallas gynecologist who walks screen daughter Kate Hudson down the aisle in *Dr. T and the Women* (2000). His character, Dr. Sullivan "Sully" Travis, believes "all women are saints" in this film from director Robert Altman. The heavenly female cast includes Hudson (as Sully's eldest, Dee Dee), Liv Tyler, Laura Dern, Helen Hunt and one-time poster pinup Farrah Fawcett as Mrs. T. There were far fewer women, but no less saintly, at his own wedding in 2002. Gere married Carey Lowell at their Westchester County, New York, home, with Lowell's daughter Hannah and the couple's son Homer on hand.

THE WEDDING SINGER

The Wedding Singer is double the retro—set in 1985, with funny hair, an oldies soundtrack and a "good guy triumphs, gets girl" theme. Robbie Hart (Adam Sandler) sings at suburban weddings but not his own, after his fiancée leaves him standing at the altar. Cue a kind and cute waitress, Julia (Drew Barrymore), who needs to do some of her own dumping (trying out her slimy banker fiancé's last name—which would make her Julia Gulia—is her first clue). As Robbie helps with wedding plans—and finds out more about Julia's *Miami-Vice*-loving future husband—Julia's doubts grow too. Love stinks, as the J. Geils Band song reminds us in this movie, but not for long. Sandler sang one of his own compositions to actress-model Jackie Titone at their 2003 wedding. Barrymore, a marriage alum, has been in tune with drummer Fabrizio Moretti.

THE PRINCESS BRIDE

Robin Wright Penn is wispily beautiful as Buttercup, the Princess Bride, in this 1987 bedtime story. The Grimm-a-thon of comic swashbucklers follows the fairy-tale rule (true love triumphs), although the path is predictably prickly. Buttercup finds, loses and is reunited with Westley (Cary Elwes), but a wily would-be groom, the evil Prince Humperdinck, steps in. Rob Reiner directed the swordplay and wordplay that crowned this princess in Hollywood. She found Mr. Wright, actor husband Sean, on-set in 1990's *State of Grace*.

INDEX

CREDITS

TITLE PAGE
1 John Solano Photography

CONTENTS
2 Lara Porzak/Rogers & Cowan/AP

INTRODUCTION
4-5 Donna Newman

SECRET WEDDINGS
6 BEImages; 7 Taxi/Getty; 8-9 Carolyn Snell (2); 10-11 John Solano Photography (4); 12 (top) Kevin Mazur/WireImage; Riquet/Bauer-Griffin; 13 Mark Liddell/Icon Intl.; 14 Jeff Kravitz/FilmMagic; 15 **How They Met:** (clockwise from top) Joe Buissink/WireImage; Robert Scott Button; Fred Marcus Photography; 16 **Elopements:** (clockwise from top left) Angeli/Reflex News; Jan Knapik/Splash News; Jeffrey Mayer/WireImage; Jim Cooper/AP; Dan Herrick/KPA/Zuma; Todd Williamson/FilmMagic; Bruce Glikas/FilmMagic; Bill Davila/Startraks; Villard/Sipa; Marc Larkin/London Features; **Size Matters:** Alberto Estevez/EPA; 17 Sante D'Orazio; 18-19 **How They Keep Their Secret:** (from left) DP/AAD/Star Max; David Rohmer; Michael Sanville/WireImage; Illustrations by Bo Lundberg

I MARRIED A STAR
20 Michael Kraus (3); 21 Simone & Martin; 22 (top) Jonathan Alcorn/WireImage; Fame Pictures; 23 Simone & Martin; 24 Lara Porzak/Rogers & Cowan/AP; 25 Courtesy Dennis Quaid/AP; 26 Alex Berliner/BEImages; 27 **Proposals:** Ramey Photo; **Matchmakers:** Russ Einhorn/Splash News; 28-29 (from left) Regina H. Boone/Detroit Free Press; Dianne Reynolds/Photophotokauai; 30 Alex Oliveira/Startraks; 31 Joe Buissink (2); 32-33 **Queen For a Day:** (from left) Daniella Theis & Michel Guyon; Jadran Lazic/Zuma; Jonathan Alcorn/WireImage; Steve Douglass/USPix; Maring Photography/Getty

ACTORS IN LOVE
34 Daniella Theis & Michel Guyon; 35 (from top) Elisabeth Colfen/Masterfile (2); Keate/Masterfile; 36-37 Alan Smith/Signature Weddings (3); (center and bottom right) Shakerea Lawla/Signature Weddings (2); 38-39 (from left) Express Syndication (3); **Brides on the Beach:** Yitzhak Dalal; 40 **The Princess Bride:** (top) Peter Berson; Courtesy Neil Lane; 41 *1, 5:* Courtesy Neil Lane; *2, 4:* Peter Berson; *3:* Jonathan Alcorn; 42-43 *1:* David Rentas/New York Post/Rex USA; *2, 5, 6:* Courtesy Neil Lane; *3:* John Solano Photography; *4:* Jonathan Alcorn; (bottom) Jonathan Alcorn (2); **Circle of Love:** (clockwise from top right) Mike Finn-Kelcey/Reuters; Axelle/Bauer-Griffin; Eric Charbonneau/BEImages; Gregg DeGuire/WireImage; Rodriguo-Madison/X17; John Solano Photography; 44 Dana Hargitay; 45 Warren Spicer/Getty; 46-47 (from left) Evan Agostini/Getty; Britt Schilling (3); 48 Daniella Theis & Michel Guyon (2); 49 Michael Brannigan; 50 Jim Lee/AAP Image; 51 Nick Goossen; 52 **Wedding Epidemics:** (from top) Gregory Pace/FilmMagic (2); Kevin

Mazur/WireImage; Al Marciano Photography; 53 (from top) Cashman Professional; Joe Buissink/ WireImage; Deidre Buck Photography; Chris Pizzello/WireImage; 54 (from top) Donna Newman; Mishan Andre/AP; Dianne Reynolds/Photophotokauai; Michael Tammaro/BWR PR, 55 (from top) John Russo/JME; David Edwards/Daily Celeb; Jadran Lazic/Zuma (2); Jennifer Prater

LOVE AT WORK
56 Michael Kraus; 57 Cheryl Richards; 58-59 (from left) Eliot Press/Bauer-Griffin; Tim Otto; 60 Greg Gorman & Richard Marchisotto ©Kilkenny Productions (2); 61 Tracy Niedermeyer Photography; 62 Boston Herald/Rex USA; 63 Courtesy Michelle Branch; 64-65 **Top Tiers:** (from left) John Solano Photography; Stavros at Sarah Merians Photography & Co.; Maring Photography/Getty; Courtesy Perfect Endings; Yitzhak Dalal; Simon/Ferreira/Startraks

MAY-DECEMBER ROMANCE
66 Michael Kraus; 67 Terry deRoy Gruber & Jeremy Saladyga/Gruber Photographers; 68-69 Maring Photography/Getty (4); 70 Terry deRoy Gruber & Jeremy Saladyga/Gruber Photographers; 71 Marco Vasini/AP; 72-73 (from left) Steve Douglass/USPix; Hulton-Deutsch Collection/Corbis; Bill Bernstein/Camera Press/Retna; 74-75 **Romance in Bloom:** (clockwise from center) John Solano Photography; Denis Reggie; Maring Photography/Getty; Alan Smith/Signature Weddings; Shakerea Lawla/Signature Weddings (2); Teness Herman; Greg Gorman & Richard Marchisotto ©Kilkenny Productions

IN PRAISE OF YOUNGER MEN
76 Maring Photography; 77 Foodpix/Getty; 78-79 Maring Photography (4); 80 David McKnight-Peterson/Corbis Outline; 81 Teness Herman; 82-83 (from left) Yitzhak Dalal; Santiago A. Baez/Marcel Thomas Images

PARTING WAYS
84 Image Bank/Getty; 85 Barry Talesnick/IPOL/Globe; 86 Sylvain Gaboury/DMI; 87 Chris Delmas/Zuma; 88 Mike Lawn/Rex USA; 89 (top) Fernando Allende/Celebrity Photo; Arun Nevader/WireImage; 90 Phil Roach/IPOL/Globe; 91 **The Almost Wedding:** (clockwise from center) Courtesy Harry Winston; Tsuni/Gamma; Natasha Calzatti; Tom Vickers/Splash News; Davies + Starr; 92 (from top) Jill Johnson/JPI; Trapper Frank/Corbis Sygma; 93 Arun Nevader/WireImage

LOVE AT LAST
94 Mirrorpix; 95 Corbis; 96-97 (from left) Ian Jones/Gamma; Nunn Syndication; Empics; Mark Stewart/Camera Press/Retna; **I Married a Commoner:** Jens Norgaard Larsen/EPA; 98 Denis Reggie; 99 Jo Von (2); 100-101 **Against the Odds:** (from left) Mikel Healey/AP; George Pimentel/WireImage; Marcio Jose Sanchez/AP; Jamie McCarthy/WireImage; 102 Serge Thomann (2); 103 Nicolas Khayat/Abaca

104 **Hello, I Love You:** Armani/AP; **Married Again:** Neal Preston; 105 Andrew D. Bernstein; 106 **Reunited:** (clockwise from bottom left) Denis Reggie; Stavros at Sarah Merians Photography & Co.; Harold Hechler/Retna; Joe Buissink; 108-109 **The Reception:** (clockwise from center) Dimitrios Kambouris/WireImage; Yitzhak Dalal; John Solano Photography; Simone & Martin; Maring Photography/Getty (2)

THE REAL DEAL
110 Yitzhak Dalal; 111 Taxi/Getty; 112-113 Yitzhak Dalal (5); 114-115 (from left) Courtesy Sam Solovey; Yitzhak Dalal (4); 116 LDP Images; 117 Rafael Photography; 118 Yitzhak Dalal; **Jitters:** UPPA/Star Max; 119 Cameron Mathison

MTV WEDDINGS
120 Rick Gayle/Corbis; 121 Simon/Ferreira/Startraks; 122-123 (from left) Neal Preston; Joe Buissink/WireImage; 124-125 (from left) Simon/Ferreira/Startraks (5); Splash News; 126-127 **Million Dollar Weddings:** (from top left); Yitzhak Dalal; Fame Pictures; Maring Photography/Getty; Greg Gorman & Richard Marchisotto ©Kilkenny Productions; **High Notes:** Kevin Mazur/WireImage; 128 (from top) Thomas Rabsch/WireImage; Big Pictures; 129 Suzy Clement; 130 131 Simone & Martin (2); 132-133 **Family Affair:** (clockwise from center) Teness Herman; Simone & Martin; Maring Photography/Getty; Maring Photography; Simon/Ferreira/Startraks; Simone & Martin; Nick Goossen

MARRIED IN THE MOVIES
134 Stockdisc/Getty; 135 (clockwise from top) Melissa Moseley/New Line/WireImage; Van Redin/Columbia Pictures/MPTV; Everett; 136 (top) Sidney Baldwin/Columbia TriStar/Kobal; Vivian Zink/Universal/Kobal; 137 (top) MB Pictures/Rex USA; Magdalene Kispal/Regency Enterprises/Kobal; 138 (top) TriStar Pictures; A Band Apart/Miramax/Kobal; 139 (top) Sophie Giraud/IFC Films/Photofest; 20th Century Fox; 140 (top) Pacific Coast News; DR T Inc./Sandcastle 5 Prod./Kobal; 141 (top) K. Wright/New Line/Kobal; Lee McLaughlin/20th Century Fox/Photofest

CLOSING PAGE
144 Alan Smith/Signature Weddings

END PAPERS
Burke/Triolo Productions/Getty; Jim Franco/Getty

COVER
(clockwise from top left) Carolyn Snell; John Solano Photography; Britt Schilling; Joe Buissink/WireImage; Simone & Martin

BACK COVER
(clockwise from top left) Alex Berliner/BEImages; Dianne Reynolds/Photophotokauai; Tim Rooke/Rex USA; Simon/Ferreira/Startraks; David McKnight-Peterson/Corbis Outline; Yitzhak Dalal; Jadran Lazic/Zuma; Thomas Rabsch/WireImage; Maring Photography/Getty

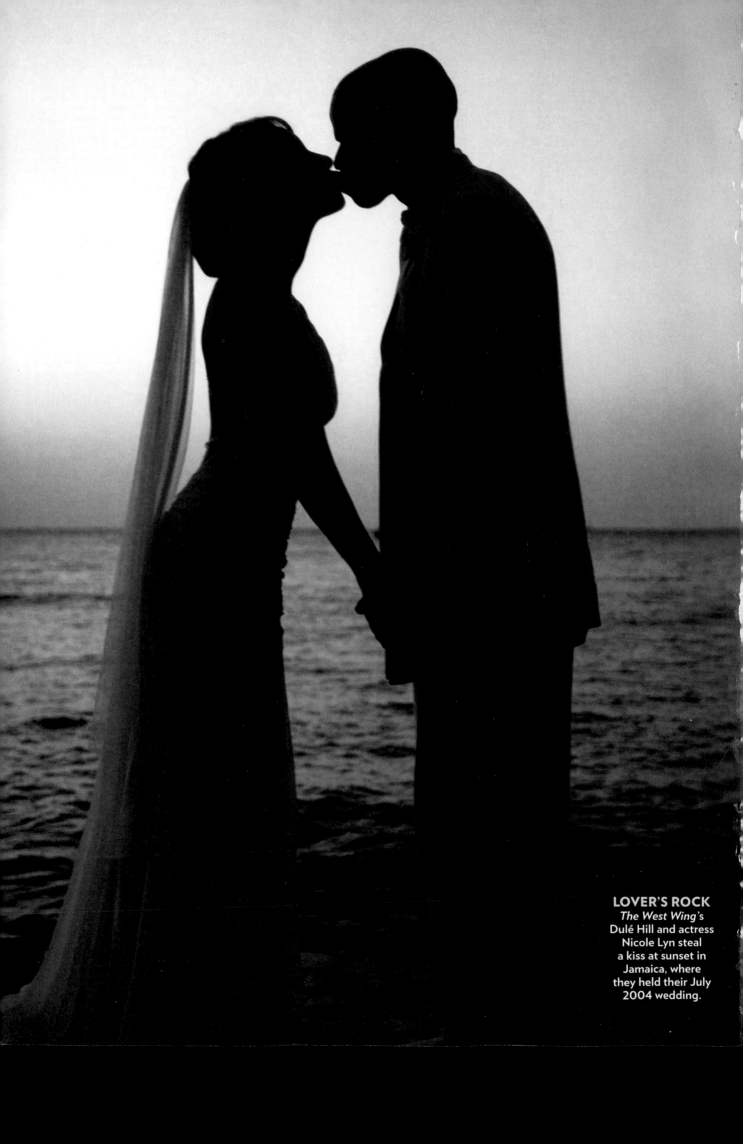

LOVER'S ROCK
The West Wing's
Dulé Hill and actress
Nicole Lyn steal
a kiss at sunset in
Jamaica, where
they held their July
2004 wedding.